Raw art Journaling

Quinn McDonald

NORTH LIGHT BOOKS
Cincinnati, Ohio
www.CreateMixedMedia.com

15 14 13 12 11 5 4 3 2 1

Distributed in Canada by Fraser Direct
100 Armstrong Avenue
Georgetown, ON, Canada L7G 5S4
Tel: (905) 877-4411

Distributed in the U.K. and Europe by F&W Media International
Brunel House, Newton Abbot, Devon, TQ12 4PU, England
Tel: (+44) 1626 323200, Fax: (+44) 1626 323319
E-mail: enquiries@fwmedia.com

Distributed in Australia by Capricorn Link
P.O. Box 704, S. Windsor, NSW 2756 Australia
Tel: (02) 4577-3555

ISBN-13: 978-1-4403-0855-0

fw media
www.fwmedia.com

Editor: Tonia Davenport
Designer: Geoff Raker
Page Design: Adrienne Mary
Production Coordinator: Greg Nock
Photographer: Ric Deliantoni

Dedication

For Kent, Ian and Buster.
You all know why.

Acknowledgments

We don't get anyplace alone. Many people not mentioned here should be. But I'm allowed only so much space. Norine Dresser started it all by taking me seriously and laughing hard with me, too. The late Gordon Bowman insisted on creativity and imagination, even in the corporate world, even if you didn't get rewarded for it. I'm grateful to all the people who said, repeatedly, "So, when are you going to write that book?" Thanks to all the participants in my classes who asked questions, made me think hard and watched me make mistakes that led to something better. I'm thankful I had so many teachers who were inventive and helped me learn how to teach. Pinna Joseph of Changing Hands independent bookstore gave me my first chance to teach in Arizona, when I had no local track record. Tonia Davenport, my editor at North Light, deserves thanks for patience, friendship and the wisdom that "No book is written; books are rewritten," and then helping me do just that. Without the many people at North Light Books, people I never saw or spoke to, but whose imagination went into the design, marketing and details of this book, there would be no book. I'm grateful for all of you.

Contents

Create Imperfectly

You may have been raised in a very strict art-and-craft tradition. Or, no art-and-craft tradition at all. Mine was on the strict side. I had to complete a certain amount of embroidery—perfectly—before I could go out to play. There were days of no play. Later, I failed sewing class. Admittedly, I have measuring problems. No matter how hard I try, no matter how many straightedges, rulers or cutting mats I use, whatever I cut is not perfectly straight. I once purchased a used machine that you put the paper in, turned a handle and the paper came out the other end, neatly sliced in half. The third time I put a sheet in, it made a rasping sound and the paper came out crooked. I think it's me.

At any time, from age six to now, I could have given up all art forever, knowing that I'm flawed. But I don't make art to be perfect or to produce what someone else defines as art. I choose to make meaning, not perfection. Through art, we figure out who we are and where we are going. Art made under those circumstances is what I call "raw art." It's the art in my journals, and I invite it to be the art in your journal, too.

When you create because you love the act of creation, the fun of problem solving and seeing the project move ahead, you are an artist creating personal, powerful art—raw art.

One of the great joys of accepting your imperfection is that it frees you to create imperfectly. I wish it hadn't taken me so long to understand that, and I hope you catch on much faster than I did. You are holding this book in your hand because you are curious, maybe daring. Welcome. Turn the page and let's get started.

What's Raw
Art Journaling?

A raw-art journal is a way to keep track of your life—the journey you experience as you decide what you want to be when you grow up (even if you are physically grown up already). A raw-art journal is *your* work—not something you make to show or give to someone. It's a private piece of work, one in which you make meaning—a sense of your work, your family, your dreams.

You might have kept journals before. Maybe you wrote a page every day. In a raw-art journal, you can write just one word if you want. Maybe you tried to create pen-and-ink drawings with watercolor washes. Here, you'll see how you can use lines and figures that you make up and that have big, emotional meaning to you. You can experiment; you are free to mess up. Nothing can hold you back because a raw-art journal is always fixable, always changeable. You can leave pages half-done and come back to them later. A raw-art journal is a work in progress—just like you!

What if you can't draw? Not a problem. A raw-art journal doesn't require you to know how to draw. Drawings can be disappointing if your completed piece doesn't look exactly like the object you saw. Raw art frees you by using abstracts, designs, words-as-pictures, collage and images you see in photographs.

You'll learn many techniques in this book that will allow you to love your art without knowing how to draw even a stick figure or a straight line.

If you can't write, raw art is just what you've been looking for. You can use one word or a phrase. Later in this book, you'll discover found poetry—using a page of a book or several pages of a catalog and hunting for words or phrases that make a new kind of sense to you. You'll also discover that a few meaningful words are better than pages of not-from-your-heart writing.

You get better at dancing by dancing. You get better at skiing by skiing. You get better at creative work by doing creative work. Your creativity needs feeding and care. If you ignore it, it will wither. Taking time to write, draw, paint and collage regularly are ways to get better at them. But there is another benefit to spending time in creative work—it helps you figure out your problems, see what you want to become, plan your journey, discover your purpose in life. Are you frowning because it sounds too big? Not at all. Creative work is the act of *creation*. It's important work. It can calm you, inspire you and help you make meaning from your life. And that's all the more reason you need to create something every day—to make meaning.

Making Meaning, Making Art, Making Mistakes

Making meaning, making art

Raw art allows you to acknowledge a creative impulse you feel strongly and to tap into your imagination (and your true self) to make meaning with your art. We do not *find* meaning in life; we *make* meaning *from* life. When you sink into your creative work so thoroughly that you forget what time it is, you are making meaning. When you have an "Aha!" moment, you are making meaning. When you happily work on your art without critiquing yourself, you are making meaning with your art.

Raw art is the work you know how to do when you experience meaning-making. Raw art is not something you have to sell to feel good about; it is not something that requires kits and expensive equipment. Raw art starts with your insight into life, grows through your satisfying creative work and brings you pleasure from the work that helps you see your own journey through life a bit more clearly.

Making mistakes

Raw art doesn't require a pile of art supplies. All raw art requires is a full heart and an open mind—open enough to fill it with new ideas, new images, new words. Raw art *thrives* from experimenting, from making mistakes. When you do something right, it's easy to miss what worked, *how* it was right. You probably don't often think, "Wow, that journal page is just what I wanted it to be. It must be the balance of secondary and accent colors and the application of the rule of three." That's not how growth works. But when you make a mistake, you can see and name what you did wrong, and you can decide not only to change it, but *how* to change it. You give yourself choices and choose a better path to the result.

The decision to change leads naturally to curiosity and experimentation. You try one thing, see if it works, then try another. This is the heart of success. Experimentation is messy fun done with no expectations. It's play. Experimentation is not caring about the outcome, but caring about the fun of seeing what happens—and that is raw art.

Dealing With the Gremlin

So, what gets in the way of play? Your own negative self-talk—the defeating, horrible things you say to yourself that deflate your ego and try to squelch any talent you may have. Does any of this sound like what you say to yourself?

"You're no good at this, why even try?"
"You call this art? Who would buy this mess?"
"You're not really an artist, you never will be."

This negative self-talk is a gremlin that chews through your self-confidence and self-esteem. The gremlin is not ready for your creative growth; it is ready for lack and attack, so it is always pointing to how you will fail, starve and turn into a bag lady, even if you are a man. The gremlin is always ready to challenge play and turn wonder into gnawing self-doubt. Everyone has a gremlin, but artists have big, powerful gremlins because for years they have been told that creative work is not "real" work. Creative work is suspect because it might be fun, and certainly, if we have fun, we will do nothing important. Creative work is the reason we are on earth. Creative work connects us all. Your gremlin is a part of you, and you cannot get rid of it, because it lives in your brain, but you can distance yourself from the negative self-talk. You can, with practice, tell the gremlin to shut up, and do it successfully.

How do you shut up the noise from the gremlin? You confront, you confine, you confound.

My gremlin is a series of triangles—sharp points that he uses to poke and bother me.

Confront

Recognize the gremlin's voice so you can separate it from your creative work. Become familiar with the most common phrases you hear in your head. Create a mental image of your gremlin. It is easier to distance yourself from the lack-and-attack messages if you create a picture of your gremlin as a nonhuman sort of figure—something like a monster. Use your imagination to create a visual of all the things the gremlin represents. Make it ugly and mean—and not you. Distance yourself from the negative influence.

Write a description or draw your gremlin on a sheet of paper—not on a page in your journal. (Once a gremlin is in your journal, you'll keep running across him. Use a separate piece of paper.)

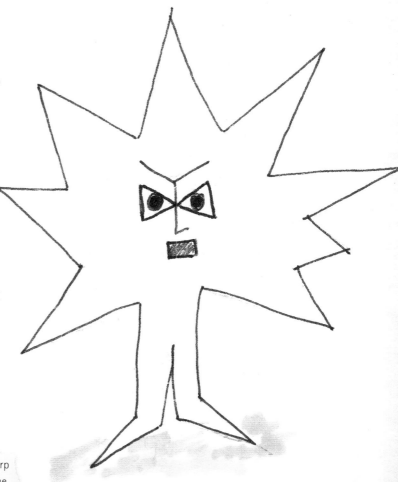

Now divide the paper in half. On the left side, write down what the gremlin says most often. On the right side, write a response to each comment in positive terms. If your gremlin says, "You're not an artist," write that on the left side. On the right, you might answer, "I create fine art; any art I create is fine with me!" (Thanks to Lynn Trochelman for sending me that wonderful piece of wisdom!) Keep writing till you feel better. You can do this exercise as often as you like. It works over and over again.

What the gremlin says		Rephrased as encouragement
"You aren't an artist."	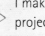	I create fine art; any art I create is fine with me!
"You'll never be able to sell this."		I'm going to satisfy myself first, then decide what to do next.
"Who cares about art, anyway?"		I make time for creative projects because it's important to me.

You can also draw an image of your gremlin and have speech balloons coming out of his mouth. Spend some time creating the gremlin. If you can't draw, that's fine. You can just use lines and shapes to represent negative energy.

Confine

When you draw and write about your gremlin on a separate sheet of paper, you can control what happens to it. Put it face down in a drawer when you begin your creative work. Fold up the paper and sit on it while you are in your studio. Crumple it up and throw it into a corner or out of the room. Separating yourself from your gremlin is powerful. The image of throwing the beast away from you, or putting the paper in a place where you can't see it while you work, gives you real power. Always distance yourself from the negative self-talk when you're in the studio.

Confound

You are intimately familiar with your negative self-talk. You probably play it as background noise in your head. When you take charge of your creative work, you befuddle the gremlin—reduce its power and hold over you. That's exactly what you want. For this reason, don't destroy the paper. Negative self-talk has been a part of your life for a long time, and you need to keep finding new ways to distance yourself from your gremlin. Physically being able to displace the gremlin as it lives on the paper allows you to do this most easily. Confounding him over and over again clears your head.

Distancing Yourself From Your Gremlin

- Draw him on a sheet of paper separate from your journal. You are in control of the piece of paper. Hang it on your bulletin board to remind yourself to answer the negative self-talk with positive statements.

- Use the piece of paper to confine the gremlin. Every time you start creative work, talk to the gremlin as you put it out of the studio or face down in a drawer. Limiting the time the gremlin can talk to you limits your own negative self-talk.

- Create a ritual of taking the gremlin out of your studio while you work. Make it part of how you start your creative time. Find funny places to put the gremlin—under the door-mat, in the linen closet, under the spare toilet paper rolls—to remind yourself that he has no power over you.

- Draw your gremlin to suit your mood. Some days he might be ugly and mean, some days he'll be all eyes—the better to criticize your work—some days he'll have a tail and horns. If you don't want to make him a monster or reptile, you can use lines and shapes to create tension. You'll get better at this over time.

- Even when you are not in your studio, watch out for negative self-talk. Replace it with something positive that is true. If you are scared to talk to people about your art, instead of using "I'm not scared," say, "I'll understand my art better if I explain it to others," as a positive replacement.

Various gremlins

13

Raw Materials

Raw-art journals set your imagination free. You don't need a pile of special equipment, you don't need kits, you don't need to copy anything anyone has ever done. You are enough, you have enough. Let's get started by picking a journal.

Journals

I get asked all the time, "What's the *best* journal?" or, "Which one should *I* use?" I use a number of journals, each one for a different purpose. On the opposite page is a chart of my favorites. That said, there is no *best* journal; *use more than one!*

This is particularly true if you are a perfection-ist. You might want to keep a journal/calendar for business. In it goes your to-do list, notes from a phone call, the address of that meeting, directions on how to get there, reminders, quotes you read. This is a messy journal, a way for you to see what you did when, track progress, check expenses and round up other work-related information. It is also a treasure trove of ideas for another journal. Those random-line drawings, quotes and other tidbits are the scraps of ideas to build another journal. You might also want to keep a journal just for dreams, or one for sketching ideas to save for later.

Journal Type	What Works	What Doesn't Work
Index cards: Date them, write/draw on them, keep them in a box.	Quick thoughts, quotes, lyrics, poems, sketches, multimedia work, collage. Grab a random handful of cards you've completed from your box—something new comes up/is revealed every time.	Long journal entries or stories that continue from page to page, double-page spreads, work that needs to be kept sequentially.
Wire-bound books: Choose lighter paper for sketching, heavier paper for mixed media.	Writing, sketching, colored pencils, stamping, some inks. They come in a variety of paper weights, color, texture, formats. A coiled spine makes it easy to fold back the cover for support while writing or sketching.	Double-page spreads, acrylics or work that uses pastes (the wire gets gunked up, making pages difficult to turn). Bulky to carry in a bag. Lightweight papers warp with wet media.
Traditional-bound books	Writing, sketching, stamping. They come in a variety of papers perfect for inks, acrylic, watercolor, collage, mixed media. They also come in a variety of formats and covers.	Most don't lie flat, so they can be challenging to draw in as well as to dry wet work.
Movable pages: This includes ring binders and Rollabind.	Freedom to use a variety of papers and consequentially a variety of media. You can also take pages out to work on them independently. You can include pockets and photo pages.	Most binders come in large sizes with vinyl covers begging to be either hidden or personalized. They are bulky to travel with. Rollabind requires a special hole punch and special discs.
Make your own	Assemble/bind as you like when your pages are finished, making it easy to avoid having to rip out unwanted pages.	Not everyone likes making books.
Adopt-a-book	There are many choices at used bookstores, and they are inexpensive. You can alter all or some pages, and some, such as music or atlases, provide an interesting background.	Pages require some prep—attaching new pages, removing pages, covering existing pages with gesso.

Everything Else

Start simply. If you already have a huge stash of materials, you will feel relieved that the simplest journal is a piece of paper and a pencil or pen. An accordion journal (with pages folded like a fan) provides you with a variety of page sizes and tucks in a book you are reading.

Journaling is addictive, and you can add to your raw-art journaling stash with a huge variety of tools. Here are the basics that will get you started.

Pencils: A good pencil to use is an HB, right in the middle of H—hard, and B—soft. Look for a number next to the letters. The higher the number next to the H, the harder the lead. Hard leads don't smear and keep a point, but they also leave dents or grooves in the paper that can't be erased. Hard leads also write lighter than soft leads. The higher the number next to the B, the softer the pencil. A 6B puts down a dark, smudgy line that can be used for shading. Softer leads leave a darker mark that's easy to put down, easy to erase and doesn't leave a dent. Because they smudge easily, you'll find it's easy to smear what you've put down with your fingers or by rubbing against other pages when you close the book. Soft leads also need sharpening more frequently.

Eraser: A kneaded eraser looks like a piece of gray clay. The more you squeeze and pull it, the softer it gets and the more you can shape it. They last a long time—until they are black all the way through. You can also try white and black plastic erasers.

Pens: From fountain pens to sparkly gel pens, this versatile writing instrument is also used for drawing, coloring and mark-making. Gel pens come in a huge choice of colors and flow—some leave a raised line, some have sparkles. Pitt Pens are fiber-tip, fast-drying, archival, permanent-ink pens that come in a variety of tips, from brush to wide to extra-fine, and come in many colors—available in sets or individually. You can also write with ballpoint pens, rollerball pens or fountain pens. If you use a fountain pen, you have a big choice of ink colors. The inks can be used to splatter, paint or drip on the page.

Scissors and other handheld cutters: I like large sharp scissors for cutting out accordion books and tiny sharp scissors for cutting words from a page. A small box cutter or craft knife is very versatile once you get used to it. Whatever you use, keep the blades sharp. Finding an excellent scissor-sharpening service is as important as frequenting a good hair salon.

Glue: There are as many glues as there are journal pages. A glue stick travels well and isn't messy. I've never gotten the hang of making them last, though. PVA (polyvinyl acetate, if you really want to know) is the generic term for white glue. There are many brands. Choose an archival one and use a small, refillable bottle with a pointy tip. Gel medium is essentially acrylic paint with no color in it. It makes a good glue as well as a cover layer for collage, but it takes a bit of time to dry. Its original purpose was to slow the drying time of acrylic paints. I prefer to use a varnish (Golden makes a popular one) for the final coating over a layered page because it is flexible and dries quickly.

Brushes: You don't need to spend a fortune on brushes, but try to avoid buying cheap ones, even though it's tempting. You will spend a lot of time picking dropped bristles out of your work. Buy student-grade brushes (on sale) for painting. Brushes also work well for gluing small areas. Rinse them immediately and they will last a long time. For big areas, you can use a foam brush, but it will suck up more glue than a bristle brush.

Camera: The best camera is the one you have with you. You don't need an expensive camera to remember the wording on a sign or to remember what kind of flower you found. The one in your phone may be enough.

Phone book: These handy free books are extremely useful for gluing. Smeared glue is a problem for journalers, and for some reason, we all become stingy when it comes to using fresh paper to glue on. Put whatever you're gluing on a page in the phone book, spread the glue, pick up your journal page and turn the page on the phone book. It takes a long time to get through a phone book. They are also handy as a book cradle—to punch even holes to stitch journal pages together.

What's Left?

Raw-art journaling is a low-stress project. You can collect wonderful shades of acrylics, pens filled with poster paints, even a sewing machine. There are elegant handmade papers, tags, cards, lettering sets, calligraphy pens, die-cutting machines and stencils. You can have as much fun as you have cash. Yet, one of my favorite journaling activities is to make journaling tools out of household supplies. A foam

brush that is used up makes an interesting writing instrument if you pull off the foam. Chopsticks, small tree branches, toothpicks and coffee straws all make great writing instruments. Pick a dry, sturdy flower stem and beat the end with a small rock until it frays. Then use it as a brush or pen. A string soaked in bleach and dropped on a piece of colored paper bleaches a random pattern on the page. Dip another string in ink, and you have a freeform border on the page. Beet juice (raw, from a juicer) makes great ink for dip pens.

Don't follow directions. Strike out on your own. See what happens.

Facing First Fears

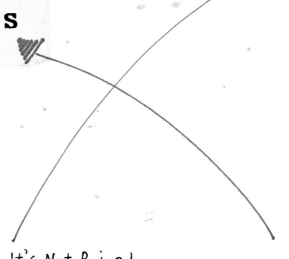

Getting Over the Blank Page

That first blank page in any journal is so intimidating. It's so *empty*. It demands so much from you. The trick is not to overthink that first page. Here are five ideas to help you get started.

1. Write a favorite quote on the first page. Then add your name and email address in case you lose it. Now you can go on to the next page.

2. Create a simple design or motif and use it on all the first pages of all your journals. I use two crossed lines, each tipped with lines that form a triangle. Once you know exactly what will go on the first page, you are in action; it's easier to stay in action than to get into action.

3. Drop some colored inks on the first page, making little splashy blots. That's enough.

4. Save the receipt the next time you buy art supplies. Glue it on the first page and write down what you are going to do with what you bought.

5. Save the ticket stub from the next movie you see. Glue it on the first page and write down a short summary of the movie.

It's Not Ruined . . .

Once you get over the hurdle of the first blank page, you worry about what will happen if you "mess up" a page. Let's decide what the plan will be, right now, so you can stay in action. Here are my three favorite page fixes.

1. Paint over a page. Use gesso first. It's a paper primer and will cover up whatever you did. You can paint gesso over paint, collage or ink. If a hint of the previous page shows through, it makes for an interesting background. Gesso comes in white or black, and it covers well, but some inks will still bleed through. Three thin coats are better than one thick coat. If you aren't sure what you are going to put on that page yet, use a thin coat of gesso so you can decide down the road if you want to do something similar. You can put the second coat on later, when you know what you are going to do with the page (leaving some of the old work showing can add interesting layers to the new page).

2. If you don't like painting in your journal, use a sheet of vellum or cooking parchment and cover the page you don't like with this translucent cover. You can then redo the part you don't like until you get it just the way you like it. This technique also works to

18

show different colors or words, and changes what you think of as "wrong" into "one of several choices."

3. If you don't want to change the journal page by painting or cutting, use what you have and make notes of what you would do differently next time. Don't write in a negative tone, make it useful. "The sky might look better in green," or "This tree's shadow should be on the other side." I write on artist's tape and tape it right next to what I don't like. *Voilá!* You have turned a mistake into a useful tool.

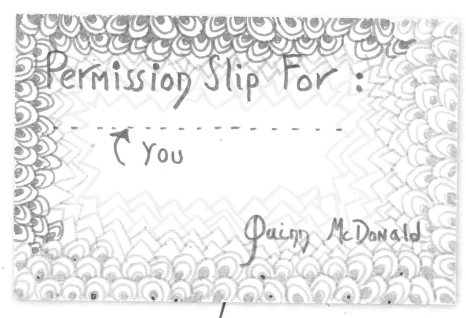

Permission Slip For :

 ⌐ You

 Quinn McDonald

Some people like to cut out and replace pages in their journal. I'm not a big fan of taking pages out of a journal. You might find it interesting to see how your work grows and changes, even if this piece is not great. Leave in those pages. However, if you want to cut out a page and replace it, here's how:

Leave a margin of at least half an inch on the spine side of the book. Use the piece you are going to throw away to measure and cut out a fresh new page. Attach with glue or colorful tape. You can also use paper that is a completely different shape—a circle or freeform piece. Using a printed page from a book or a piece of map also makes a good background for whatever you do next.

Permission Slip

The one thing we need most, and give ourselves least, is permission. Permission to go to the studio instead of doing the laundry. Permission to mess up a sheet of paper instead of getting it perfect the first time. Permission to draw freehand without a stencil. Because it is hard to give yourself permission, *I'm* giving you permission to mess up. Above you see a permission slip. Make as many copies as you need, fill in your own name and you have permission to go to your studio and make meaning!

Now that you know how to start your journal and have decided how to save a messed-up page, let's start filling the rest of the pages!

Making Meaning With Words

 Our culture places a lot of value on getting things done, and done fast. We buy journals and wonder how long it will take to fill them up. We do backgrounds for pages ahead of time so we can think of the page as semi-finished. But what if you created colorful pastel stripes in advance and then your day turns into a raw umber, cloudy day? A raw-art journal doesn't hurry you, doesn't ask if you are done yet.

Many people think of art journals as color, texture and imagery with little writing. Take a deep breath. Chase the Hurry-Up gremlin out of the room. Put the "I don't have an interesting life" thought out of your mind. Raw-art journals are not about deadlines or schedules. A raw-art journal gives you permission to be only as creative as you can be today. Creativity is what feeds your soul and keeps you thriving. A raw-art journal is a place for you to play without rules, to discover who you are, to admit what you love and to give voice to what you fear. In your journal, you can discover where you have been and plan the way to the future and still stay, mindfully, in this moment. You invent and reinvent yourself in your raw-art journal.

One way you feed your creativity is by playing with words. In this section, you will discover new uses for words, how to gather them, how to chase them and how to laugh with them as if they were friends. Words will never again seem like a chore to you. They will become the witness to your dreams and the comforter of your soul. You have an endless supply of them and they are free. You can choose your favorites and banish the ones you hate. Words are never used up. You can create a prayer or a wish, cast a spell or vanish into your dreams. Words are always ready for you to gather and love.

21

Found Poetry

Sometimes life doesn't present daily events neatly and ready to put on a journal page. Those are the days for found poetry—an interesting way to explore your emotions that results in a visually textured page.

If you love the sound of words, if you hear the heartbeat of the language when you read or listen, you will love found poetry. Found poetry is already there, hidden from easy view, waiting to be discovered. If you already write poetry, great! Found poetry may be just the thing you need to freshen up your creative spirit. One wonderful thing about this process is that you don't have to know how to write poetry. You only need a sense of adventure so you can discover it.

Found poems make wonderful journal pages. Prepare your journal page by first painting or stamping a collage background on it. Or, if you like, you can also create the entire found poem on a beautiful blank piece of paper, then glue the paper into your journal. Because completing a found poem results in a collage, you may want to keep the background simple. If your magazine is black print on a white background, don't be afraid to introduce some color onto your page.

There are a few rules about found poetry. We're going to take a look at them so you can decide if you like them and will use them, or if you find them irritating and will choose to ignore them.

1. Choose a piece of text that you can cut up. Anything is fair game—magazines, catalogs, even books you own and don't mind tearing pages out of.

2. Off-limits are books of poetry (that poetry is already done, you are building your own), song lyrics, greeting cards and anything that has polished, arranged words—advertisements, TV jingles or children's books in rhyme.

3. You can't change or alter any of the words unless you cut them apart—if a word is "glow" and you need "glowed," you will have to find the "-ed" part in the same magazine article. If you need "run" and you find "ran," you have to keep looking, or find a "u" and substitute it.

Once you know how following the rules feels, you can decide to keep doing it that way or break the rules as you see fit. Sometimes rules create a path that you can follow until you understand enough to strike out in a different direction.

Found Poem from a Magazine

Discover interesting poems hidden in catalogs and magazines. When you *write* poetry, you have to choose a topic and plan how to make it work. When you *find* poetry, you let your heart choose the subject and the words. Found poetry helps your inner perfectionist let go and relax. Found poetry often looks rustic because it uses different letters and words of different sizes, colors and styles.

What You Need

magazine, catalog or book page

pair of sharp, pointed scissors

craft knife or small utility cutter

tweezers for picking up small pieces of paper

cutting mat

small bottle of glue with a pointed tip, or a glue stick

paper: approx 5" × 8" (13cm × 20cm) in a color darker than white, 2 pieces. Note: It's good to use a color that is easy on your eyes, such as pale gray, tan, blue or green. One of them will be your working sheet; the other will hold extra words and phrases.

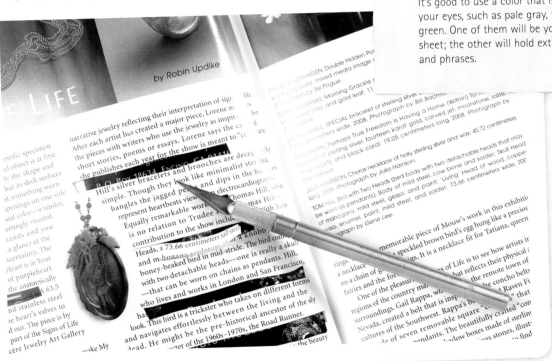

1 Start cutting out words and phrases that you like, using scissors or a craft knife. Feel free to use words in the headlines or captions of photos. Found poetry is word art, so it is not important that all the words you use are the same size or typeface.

Put the words and phrases on one of the pieces of colored paper as you cut them out. Don't try to make sense of them too early. Sometimes you may cut out a line and fall in love with it, but can't find anything that works with it. Don't be discouraged; keep looking.

Cut out words and phrases till you have about 50 pieces. Look for words that create interesting thoughts or ideas. Found poems don't have to rhyme. They only have to say something that you like. The thought doesn't have to be whole or grammatically perfect—just powerful. Tweezers will help you move the small pieces of paper easily.

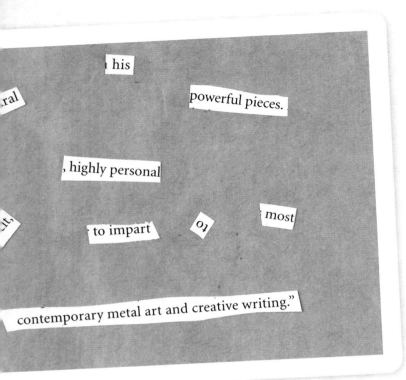

his

powerful pieces.

ral

, highly personal

to impart ot most

contemporary metal art and creative writing."

2

Begin arranging your words and phrases on the paper. Once you have the basic idea down, start to work on making the grammar right, if it's important to you. Put in or take out the "s" and "-ed" needed, put in capitals and so forth. Feel free to add commas or periods with a fine-tipped pen or cut those out too, if you wish.

3 In this example, I started out with "a magical, mythic, exquisite vision of life," and thought that was the beginning. But when I looked at the other words, I saw, "in a small, coastal community in Alaska lives," and I realized the poem was about how we live our lives more than just having a vision. Recognizing how we live our lives in winter makes it more difficult and more beautiful. I didn't write the poem—I saw it and felt it.

When you are satisfied with the poem, glue it down. You'll notice that I did not try to make it perfect. The nature of found poetry is that it comes in pieces and scraps. Trying to make it perfect is impossible. It has the look and feel of a ransom note—and you are ransoming a new meaning from an article or from a story that was about something else entirely.

in a small, coastal community in Alaska lives

a magical, mythic, exquisite vision of life.

She was intrigued by the wary-eyed creature

resonant and hard to decipher.

her intimate relationship with the

fragility of our human heart crafted

additional meaning to

the edge of beauty and mystery,

Because you are using different sizes and shapes of letters, the finished look will always be random and rustic. That is part of the charm of found poetry.

When the poem is done, add a title if you like, from words you find in the article, in ads around the article or from somewhere else. Finally, add the name of the magazine and the title of the article, the date of the magazine and the pages it came from. This recognizes both the origin and your talent in making something new from something old.

If you like rules because they make you feel organized and on time, you can create your own rules to give yourself more of a challenge:

- Use only one page of an article
- Use words, but no phrases, from the ads on the page.
- Cut out words for only 15 minutes.

Make up rules that push you into more creativity, but ignore those that limit your imagination.

Making it Easy to Create Found-Poetry Pages in Your Journal

1. To cut phrases out of a magazine page, slip a thin cutting board (the flexible kind you cut chicken on) or a self-healing cutting mat under the page. This keeps the utility knife from going through more than one page. You might want to use other phrases in the same magazine.

2. If you are cutting out words or phrases, make the horizontal cuts first. Use tweezers to lift the cut line and snip through the short ends using scissors. Using the utility knife to cut through the short ends can rip the paper and cause missing end letters. You can be more precise if you use a utility knife for the long cuts and small, sharp scissors for the end cuts.

3. Don't throw out the leftover cut-out words. Use a piece of paper folded in half and write the name of the magazine on the front. On the inside, glue the phrases and words using a repositionable glue stick. That keeps the words neat and ready to use.

4. Repositionable glue also works while you are working on a poem. If you are working in a room with a fan, an open window or a cat, the glue keeps the words where they belong.

5. If you don't like the idea of glue, you can buy small glassine envelopes at a store that sells equipment for stamp collectors. Larger ones come free with stamps you buy at the post office; you can cut them down yourself. You can also make fold-over envelopes with leftover tracing paper or vellum.

Found Poem From Book Pages

If you like the challenge of finding poetry in magazines, you will want to try the book version of found poetry. There is no cutting involved, just careful looking. It's a little more challenging than the magazine version, but it is also very satisfying. Since you are going to make your own poem, don't use a book of poetry, song lyrics or one that is heavily designed to give emotion to the writing. That's the fun part *you* want to do.

Read through a few pages of the book you are going to use until you find a page that has interesting words and ideas on it. Tear the page out of the book. Start at the top of the page and circle a word or phrase that appeals to you. Use just part of a sentence in the book; your poem has nothing to do with the plot of the book.

You can choose one word from a line and then find another word farther down the page and a phrase a few lines later. Circle the part(s) of the sentence you need. Don't worry about punctuation or capital letters; you will put in what you need with a fine-tip pen later.

1 Use a light touch on the pencil because in the first draft you may circle more words than you need. Read through your selections from the top of the page to the bottom to make sure you have captured a complete and interesting thought. If you need to add an "-ed" or "-ing," look for them after the main word. If you have words you won't need, use an eraser to remove the circles around them, leaving just the words you want for now. When you are finished, read the poem aloud to feel the full force of it. The poem here reads:
"the crescent moon was rising with silvered streaks in a flicker of light,
hurried on as blessings that have fallen from the sky.
They had moved with the detailed work of strange angels."

Now you are ready to make the words stand out.

What You Need

pages removed from a book (Novels often have more interesting words than textbooks or nonfiction books, but
play around with a variety to see which you prefer.)

HB pencil

eraser

newsprint or other paper to protect your desk

acrylic paint

small paintbrush, flat on top

colored pencils, markers, crayons

THE FALL OF LIGHT

the crescent moon he could not tell for sure if the old man was still living, and he got to his knees beside him in the snow. Then he lowered his head until it lay on the other's chest.

"Teige son," said Francis with his hollowed eyes staring at nothing. "Teige son, 'tisn't all over. We'll find them, we will. I found you, didn't I? And I have been drowned and in a place where none or few have come back and yet here I am. Teige son," he said, and raised one hand out of the wet and melted ground and lifted it to touch the boy's head.

They lay so a while. Then they rose and moved into the shelter of a roofless cabin, and Teige tethered the pony and they slept.

It was the pony and not the thieves that woke them. Dawn was rising with silvered streaks when they opened their eyes. There were figures there. At first they could not separate them from the gloom and they seemed like insubstantial fragments or velvet shapes come alive as the light thinly cracked the morning open. There were three or four of them. Francis sat upright and called out. The pony was being led away on its rope and was resisting and turning about in the road and making a long whinnying of dismay. One of the thieves smacked it hard across the face and shouted and pulled down on its rein as the pony's fright worsened and it tried in vain to rear on its hind legs. Teige was up and running then. He was a flicker of light, and then shadow, and his father was behind him. They hurried on the slippery road, crying out and making such sounds as they hoped might ward off the thieves. These last, vagabond and itinerant, had come on the two figures lying on the road and had at first supposed them dropped dead from exhaustion and hunger and the ways of the road. They had approached them the way men approach blessings that have fallen from the sky. They had quickened their step and moved around the fallen, examining their clothes and small belongings and beginning whispered argument about possessing the pony. There were three and a boy, they were blackened, their heads hatless. One with the toothless and sunken expression not uncommon then shook his head and held a stub of finger to his lips when he had discovered the father and son were alive. In the obscurity they had moved with the infinite care of those engaged in detailed work of jewellery or silversmithing. They had fingered the rags of the sleeping in absolute silence like some flimsy wraiths or strange angels elected to divest and prepare the mor-

93

95

107

2 Put down a sheet of newspaper to protect your desk. Then, using acrylic paint and a small brush (one shaped flat across the top works best), carefully paint around the words you want to show. Doing this first helps you cover the rest of the page more quickly. Paint slowly, using small strokes. You want to surround each phrase completely. Words that are divided at the end or beginning of a line should be free of paint at the end of the line and have the hyphen visible. In this example, I used Golden's Titan Buff, but you can use any brand or color you like. Put on just enough paint so the un-used text words are visible but not readable. Only the words in your poem should be completely free of paint. The rest of the printed page, top to bottom and left to right, should be covered with paint. I like to leave the margins unpainted, but you can paint the entire page. Let it dry completely. If the page curls, tape the corners to the protective paper on your desk. This poem reads:

"The curved branches bent down and
began to push the snow
in the dawning light,
in the middle of the country of the lost.
Blackbirds looked away,
filled with tangled memory and grief."

3 Some people are finished when the painting is done. You don't have to be. If you use a light-colored paint on the page, you can then help the reader's eyes move over the page smoothly, by highlighting the phrases. Using colored pencils, crayons or markers, create a visual path by using dots, lines or arrows to show the connection of the words. Don't be shy. If you love color and texture, this is the time to add it. Did you use a dark color to paint the page? You can create the path using light-colored inks, glitter gel pens, metallic inks or light-colored pencils. This is your poem; embellish it in the way that makes it come alive for you. The poem here reads:

"Then, at the end of summer, they set out
into winter and the wind blew knives past their ears.
They looked for enlightenment like a beast
In the unearthly silence."

The Curled Page

Most book pages are thin and will curl. You can reduce the curling by painting the back side of the page with paint or gesso when the front is completely dry. If you are going to glue the page onto your journal page, you don't need to paint the back because the glue will stretch the paper. If you want to use tape to stick your poetry page into your journal, paint the back of the paper to avoid warping and pulling against the tape.

Hints for creating special found poetry

- *Use a catalog to make found poetry. Pick one that sells things you like. There are catalogs that contain only books, electronic toys, dolls or jewelry. Each of these catalogs uses special words that suit the topic. These words have a depth of meaning you can use to make your poetry authentically yours.*

- *Move out of your comfort zone. If you like books, choose a jewelry catalog. You will be amazed at the poetry you create when you make meaning using unexpected sources.*

- *Flip through a magazine without really reading it. Skim articles. The words that are special to you will catch your eye. Mark the pages for use later.*

- *Try art books for a source of found poetry. Look through the table of contents to find a style you like; then use that chapter for your found poetry.*

- *Use your dreams. Write them down in as much detail as you remember as soon as you wake up. You will forget the colorful, magical details within a few minutes of waking up, so keep a notebook on your bedside table. Then use words and phrases from magazines to describe the dream or the feeling you had after the dream.*

first

THE JOURNEY BEGINS

With More Fun for

You .

Finally,

HAVE A DIFFERENT

ROAD TRIP

Cyndi Pfeiffer

Cyndi Pfeiffer

FOUND POETRY WORKSHOP

JANU.

Journey Cole

KATHERINE MANSFIELD

It won't last, Now I feel that a man who has worn out—but bear it—bear it! A man... musical world so to spend his... pain does not last forever, it is only... need to acute sens... it is as though a ghastly accident had happened. If I can cease reliving all the shock and horror of it, cease going over it, I will get stronger.

Here for a strange reason rises the figure of Doctor ... was a good man. He helped me not only to bear pain but suggested that perhaps bodily ill-health is necessary, ... repairing process, and he was always telling me to consider how man plays but a part in the history of the ... simple kindly Doctor was pure of heart, as Tchehov... of ... t. But for the... one is one's own... if... is not a repairing process... will make it so. I will learn the lesson it teaches. These are not idle words. These are not the consolations of the sick.

Life is a mystery. The spiritual pain of these letters will fade. I must turn to work. I must put my agony into something, change it. "Sorrow shall be changed into joy."

It is to lose oneself more utterly, to love more deeply, to feel oneself part of life—not separate.

Oh Life! accept me—make me worthy—teach me.

I write that I look up. The leaves move in the garden, the sky is pale, and I catch myself weeping. It is hard—it is hard to make a good death . . .

September (1922)

My first conversation with Orage took place on August 30, 1922.

On that occasion I began by telling him how dissatisfied I was with the idea that Life must be a lesser thing than we were capable of imagining it to be.

327

30, 2010

...ual Traveler

your
s
you?

n your soul?

it?

EK

Rita Ackerman

ACK TO YOUR SELF

cover
SELF

Playing With Words

Words surround you. You don't need permission to use them or experience to play with them. Words can be art or toys to play with—and in a raw-art journal, they can be both. You can explore their meaning, sound and texture. On some of the pages of your journal, words will give you meaning, insight and just plain fun. In this section, we're gathering words for meaning-making.

Even in short bursts, words deliver powerful messages. Remember the first time you read—or wrote—these words?

"I love you."
"Help me."
"Come to my birthday party."
"Meet me after class."
"The lab tests are back."

Short and strong, words can bring an ocean of emotion with them.

Putting words in your raw-art journal—long or short—doesn't come with a set of instructions. You don't have to write a certain number of words a day. You don't have to bare your soul in painful, secret or joyous detail. Sometimes one word is enough to bring your whole memory back. Pick a word you like. Is it hard to think of a favorite word without reaching for a dictionary? This chapter will change that.

Some of our favorite words are short and power-ful: *Yes! Why? How?* Some words you play with for fun are longer but are filled with the exact detail you need: *Pixilated. Revelation. Glitch.* Some words just sound funny and make you laugh: *Tippy. Cutlery. Blini* (yeast-raised Russian pancakes, smeared with jam or sour cream and triangle-folded or rolled before eat-ing. *Blini* is plural. If you want to eat one, it's a *blin*. There's another funny word for you.)

You can have favorite words which you like just for their sound, for their meaning, for the emotion you have when you hear them or the memory they have for you. There is no limit to favorite words. You can have as many as you like and collect them all your life. When I read Susan Goldsmith Wooldridge's *poem crazy*, I was thrilled to find another person who collected words for no other reason than pure delight and whimsy. No serious responsibility goes into collecting words you like; you can do it anytime and anyplace. You can stop for weeks or months and then do it frantically for three days. There are plenty of words; you won't run out.

Box of Words

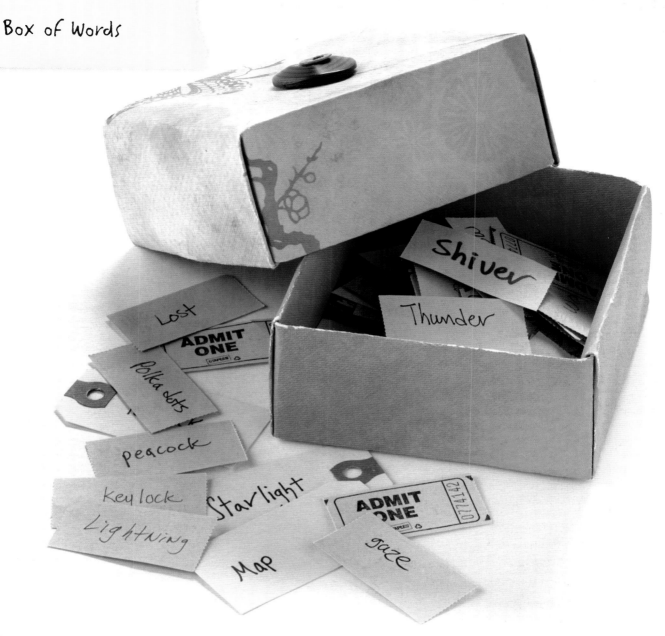

Words come and go quickly. It's easy to forget that new word you heard this morning. The shortest pencil beats the longest memory, so write down words you like. To begin your play with words, make each word feel important by writing it down on a tag—you can find tags in office supply stores, or you can make them.

You will need a special place to keep your words. A small box is fine. You can use one you already have, maybe a small but sentimental jewelry box or a hollowed-out altered book. Or, you might want to make a special box. I keep my tags in an origami box—sometimes called a Masu—that I made.

If you want to try making your own origami box, there are many sites offering directions on the Internet. A 12" (30cm) square will create a perfect starter box.

33

Here are some words you might like to put in your box:

Shiver
Journey
Petals
Tabulate
Indigo
Bamboo
Glow

To be fair, there are also words you don't like. Not just because of their meaning, but because they sound unfinished, awkward or harsh. Here are some that grate on me: *Chunky. Phlegm. Diagonal.* You don't have to have a reason, your heart knows. I don't ignore these words, though. They, too, can be added to your collection. They add a new color to the words you do like.

When you play with words, it's more interesting to collect and use words that give you a wide range of emotion. You might not like rooms that are dark, unscrupulous people or eating squash, but the words *dark, unscrupulous* and *squash* are interesting and may provide good contrast with words you do like. If you don't like the sound of a word, try using it with a word you do like to see if it creates a new meaning entirely—one you find exciting. "Dark shiver" sounds mysterious. "Squash petals" can be both an action you take and the petals of a squash plant. Words that combine to create different meanings are too interesting to discard. Some words can be both things or actions—*gauge, drill, ink, smile, drink, tree.*

Avoid words whose meaning has a strong unpleasant connotation or emotional connection. You are making meaning, not nightmares.

Should you keep words you like in the same box as ones you don't like? Try them in separate boxes first. Play with the exercises that follow and see if you want to keep them separated. You can also put them in one box and separate them by using a different color for words you like and those you don't. Or you can use different shaped tags—rectangles for the words you like and triangles for the ones you don't. Another option is to put a blue stripe on the tags of words you like and a red stripe on the ones you don't like, or make the tags a different size. You have choices, but you can also decorate all the tags just for fun and mix them together. You'll know what to do when the words begin to take on special meaning in your journal.

Let the Universe Talk

Did you ever play fortune-teller as a child? You and your friends would take turns dressing up in long scarves and hats, write predictions on pieces of paper, tuck them in the pages of a book, ask each other a question about the future, then open the book and pull out a random prediction. Maybe you used a dictionary or a Bible instead, closing your eyes, asking a question, then opening the pages at random and pointing to a spot that would predict the answer. This simple word game, which was so much fun as a child, has a grown-up version. It's still fun, and you can use your box of favorite words!

Sit down with your journal and a pen that writes in a color you love. Open the word box and draw three word-tags without looking at them. (After all, you handpicked all of these words, so you really can't go wrong.)

Put the word-tags facedown on the table in front of your journal. Turn the first tag over and look at the word. Let the word resonate with a memory. Maybe you hear a song or remember a movie or book. Write a sentence in your journal using the word. The sentence can be part of a memory, or you can make up something that is completely and delightfully fictional. This is your word, your sentence and your journal. You have permission. (Remember the permission slip? You might want to look at it again now.)

Do the same with the next word-tag. Look at it, and then feel it with all five senses. What do you think that word would taste like if it had a taste? Would it be sweet and juicy or crunchy and salty? Write a sentence using the word. Don't write the definition; write something wild. This is a word you've had experiences with. Squeeze out some of that magic and write it down.

Just one more word is left. What is the hidden meaning of that word? How can you make it come alive? What wonderful secret is just behind the ink of that word? Write a sentence in your journal that makes the word bigger than life. Write big if you have to. This is your sentence.

Look at the sentences you have written. Do they jump and run, or are they quiet and meditative? What do they say about the way you see your world? What is the universe telling you in these sentences? Write that down, too.

Look at the three words again. Put them in any order you want, and then write a sentence that uses all three words in one thought. See if the thought makes up a story on its own, or if you want to add more to make it complete.

Look at what you've written. Are you surprised at how much emotion you have created from just three words? Did you know you were this creative? Your box of words is always ready to give you a prompt. Your answers will be different every time. If you have a writing buddy—someone you meet with regularly and write with—share your box of words at your next meeting. Both of you can use the same words and come up with completely different sentences. Or you can draw different words and compare notes after you are finished writing.

Framing Words

Because words are important, don't close your journal just yet. It's time to put the sentences you wrote in the last exercise in a special place. One of the easiest figures to draw freehand is a rectangle—a figure whose opposites sides are the same length. The size isn't important, but it needs to hold one of your sentences; make it big enough so you can write the whole sentence inside the rectangle. If you printed the sentence before, write it in cursive now. Don't use a ruler or a stencil, just write and enjoy the words.

Creating space for your words gives you a sense of owning the space in your journal and deciding how you want to divide it up. You can put the rectangles in different places on the page and color around them. You can make them connect. I like the idea of showing one sentence but making myself aware that there are two more hidden. I drew the top rectangle first, then put the others in by just drawing what would show behind the first card. For fun, I drew the word-tags I used in each sentence.

Write your sentences in the rectangles. Or leave some of them hidden. You can draw on the cards if you like, but we are going to do that in detail in the Making Art of Your Words chapter (page 66). Save this work since you'll add to it later.

Thunder

Thunder ran across the sky, sending a shiver of wind through the leaves.

See, Sketch, Stack

When you draw items that are stacked, the first item you draw is the top item. This is very different than when you pack a box. When packing, the first thing you put in goes at the bottom and is hidden. When you draw, the first thing you draw is at the top of the pile, and everything else seems to be underneath it. So draw the top rectangle first, then the other two, which look like they are partially hidden by the first one you drew.

Lantern

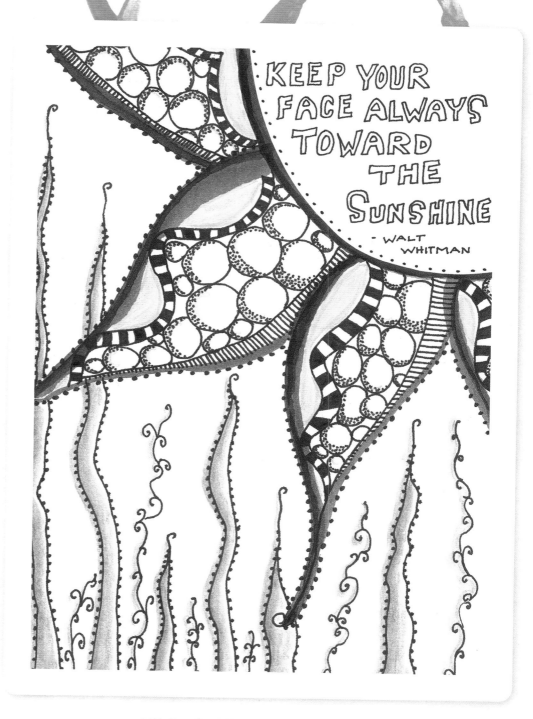

Barbara Hagerty

Words as Tarot

Tarot cards were invented in the mid-1400s as a pack of 78 cards to play card games such as *Tarocco* and *Partita*—Italian games won by collecting a trick of similar cards. By the 1700s, the cards were given a new use by mystics, who used them to discover the meaning of their spiritual journey. There are many tarot decks in use today, including the older, beautifully drawn Marseilles deck and the symbolism-rich Rider-Waite deck.

Carl Jung, the psychologist who kept the beautiful, intricate journal he called *The Red Book*, believed that the tarot cards showed archetypes—fundamental character types—and were highly symbolic.

If you love looking at the designs on tarot decks and working out your own personal symbolism, use your word box to have some fun deciphering your spiritual or mental pathway.

Without looking at the words on your tags, choose three and put them facedown in front of you. The one farthest on your left represents your past. Turn it over. Does the word resonate with an event or image from your past? Don't be too literal. Give yourself (and the word) some breathing room. For example, if the word is *clouds* you might remember playing the game "What does that cloud look like?" when you were a child. Who played it with you? Family? Friends? What do you remember about those friends? What else did you play or create with those friends?

You might have different connections with clouds. Maybe there were clouds painted on the ceiling of your bedroom or a cloud-pattern covered your pillowcases. You don't have to reach back to childhood. Maybe you saw some big, powerful thunderheads last summer, right before you went on that romantic picnic. Give your memory permission to roam. You'll have more fun that way.

The second tag you turn over, the one in the middle position, speaks to the present. Again, let your imagination run free as you think what this word might mean to you in your relationships with your friends and family. Since this word talks about the present, think about the other meaning of present—as a gift. Is this word a gift to your situation now?

If you draw a word like *book,* you could think about a book you have read recently, but it would be a lot more fun to think about the title of a book you would write about your life. Or who would play you in a movie about your life. Write your ideas in your journal. You can write as much or as little as you like. Choose a meaningful sentence from what you wrote, and write it on a new page, along with the word from the tag and the word *present.* Write it in a different color ink or in fat letters.

The remaining word—the one on the right—is about your future. What might this word mean? Give it a meaning you would like to see come true. This is your creative play and your journal, and you can create a

big, bold, imaginative world where exciting, important and fantastic events take place in the future you create for yourself.

Consider the many meanings of your word. For example, the word *bay* is a body of water made by an indentation of the shoreline. But it is also a type of window that bows outward or a division of a space, like a parking bay at a warehouse. A bay can be a sick bay on a ship. Bay is also a howl, like that of a wolf, or a trapped position: "The stag was held at bay by the hounds." There are bay laurels that are plants and bay stallions that are reddish-brown horses. Don't let the first meaning that comes to mind limit you. Have fun and explore your words, your life and your imagination in your journal.

Save all three sentences about the past, present and future for additional use in an exercise on page 46.

What to write in your journal?

Some journals just scream for a theme. There are travel journals and cooking journals, journals about baby's growth and even diet journals. In a themed journal, you always know what the next page is going to be about, even if you haven't planned the details yet. It's a lot of ideas about one thing. Themed journals are satisfying because you can look at a lot of facets of the same topic. You can cover lots of parts of one subject.

Not every journal needs a theme, however. Your journal will take on a lot of your personality if you just show up the way you feel each day you work in your journal. A journal that has pages of writing mixed in with pages of collage and colorful blocks of poetry is an interesting journal—not only visually, but also as a map of your experiences. A raw-art journal is ready for whoever you are today, whatever you want to bring to it at the moment you sit down to create. Raw art invites your deepest meaning-making with whatever tools are at hand.

Light Up a Single Word

There are many ways to use raw-art lines, dots and curves—you can create words with them, you can surround words with them. In this exercise, you are going to draw raw art around your words, leaving negative space to form the letters. To start the design, use a fine Pitt pen. You can also use a ballpoint, fountain pen or gel pens. Pitt pens dry fast, so when you turn the page to work in another direction, you don't have to worry about smearing the ink.

Start on a fresh page of your journal or on a loose piece of paper that's a comfortable size for you. Pick a word you love. "Joy" is the word in the example shown here.

1 Hand-letter your word on a piece of paper, using hollow letterforms. I'm not good at writing straight or measuring, so I draw guidelines with the long edge of a ruler. I put the short end of the ruler flush against the edge of the paper to square up the line. In this way, I measure nothing, just use the top and bottom of the ruler to create a space about 1½" (4cm) wide. Notice that the writing isn't perfect, and neither is the spacing. The "Y" shows that I am left-handed. The drawing shows eraser marks and corrections. Your drawing will be different, but will show the same deeply personal and original characteristics. Make your corrections in a soft (2B) pencil, and when you are happy with the result, erase the stray marks.

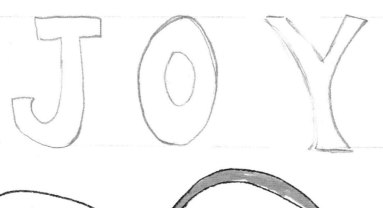

2 Now it's time to get to the raw-art part. Spend some time just trying out these patterns on a separate piece of scrap paper. Become accustomed and comfortable with the unevenness of it all. Start anywhere on your scrap paper and just draw.

I line

Arcs

You can make these as big or small as you want. You can make the first one small and the other two much bigger. They don't have to be even. You can space them so they barely touch or so they overlap. Stacks of these will look like lace or clams or doorways.

2 lines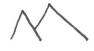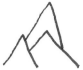

Triangles

Technically not triangles; notice how these shapes don't have a bottom part—they are made with two lines. To make them look interesting, don't connect the peaks of the triangles. Vary their sizes for visually interesting results. Stacks of these look like mountains or zigzag trim. They are not supposed to be even; they are supposed to lean and roam.

3 Lines

Rectangles

Most of these are three lines—one goes up, one across and another one down. Stacks of these will look like building blocks or a cityscape. Notice that they can tilt in different directions, and sometimes a single line or two lines are all you need, instead of three lines. This adds interest.

3 Now it's time to play with the word you hand-lettered in Step 1. Begin adding the patterns from Step 2 around each of the letters. There are no rules to do this. I like to begin one row of shapes around each letter and go from there. You can repeat lines or vary them as often as you like. Turn the page as you work to make it easier to see how the piece looks as a whole and to keep the pattern growing smoothly.

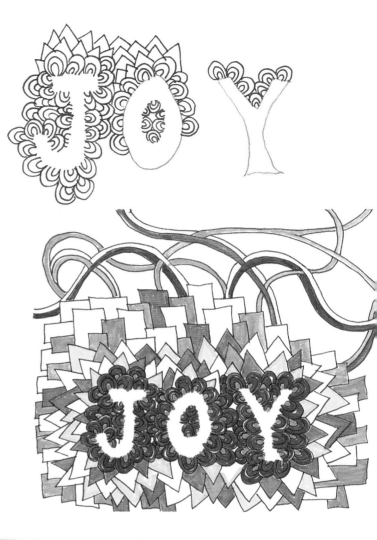

4 Keep doodling around the letters until you have a design you're happy with. Here on my page, the top is filled in with vine lines that cross over and under each other. This breaks up the page and keeps it from looking too busy. If you draw these intersecting lines in pencil first, you can define the over-and-under parts in pen without confusion. Once your letter is outlined and the ink is dry, erase the pencil marks. The letters stand out perfectly!

Now it's time for even more fun—you get to color! Grab colors intuitively. I wanted the word to stand out, so I used a light blue for the smallest arcs and did all of those first. The second arc is medium blue, and the largest is purple. If you leave a little white space, it adds depth to the completed piece. I used Pitt pen brushes because I like bright, bold color, but you can use colored pencils, watercolor pencils, crayons, acrylic paint and a brush, or other markers. You can even use a mix of them. This is about fun and color, not about rules.

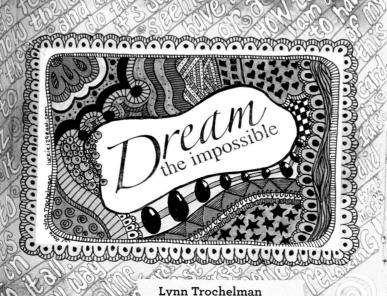

Lynn Trochelman

One-Sentence Journaling

Some years ago, a creativity-coaching client told me, "I don't know what to write in my journal. It's too much work. If I could write one sentence a day, I'd love that, but I have to spend so much time collaging, painting, gluing. . . . I'm tired before I start writing." You might love the finished page, but it doesn't mean you love the time and work of creating one.

The idea of writing can be intimidating. Maybe you aren't quite ready to write down that criticism from your friend. Maybe you don't want to admit that mistake you made—not even to your journal. And maybe, just maybe, it seems frustrating to create a background and wait for paint to dry, just so you can write on it. But still, the idea of a journal is so intriguing. Take a deep breath. You are not alone. How about a one-sentence-a-day journal? Wouldn't that take a lot of the pressure off? You've already seen how much fun and magic one word can be; what if one sentence could bring you insight, healing or fun?

Coaching clients often tell me that they don't want to write down negative thoughts in their journal because it might attract more negative energy into their lives. Luckily, your journal is not a shopping cart for energy. A journal is a place to remember and a place to forget. Journaling is magic that way; we can write down details to keep them, to bring back that wonderful weekend in all its detail—the picnic, the wine, the fragrance of a juicy, ripe melon. Once that picnic is in your journal, you can experience it anytime.

You can also pour out your heart and soul in your journal and leave it there. Pouring it out makes room in your heart for healing, for new thoughts and for insights. Once you write something in your journal, you can forget it. You can forgive. Think of forgiveness as accepting that you cannot change the past. It doesn't fix what happened, it doesn't make the action OK. It's a simple acknowledgement that past events can't be changed. It's also a powerful intention that the future can be different and new. We can learn from the past and change how we react to the memory. And a single sentence is all that's needed sometimes to put a thought to rest or to serve as a reminder for a big event.

Great Leaps in a Single Sentence

Your journal can be a treasure book of secrets and hopes, a place to put trouble to fade and joy to remember. But can you really do all that in one sentence? Sure. One sentence is all you need. If your thoughts are long, you can break them up into two or three sentences. Consider the power in the following story:

Dad fell!

Call 911. Now.

Dad, can you still hear me?

It's a complete story. So short, you could combine all three sentences in one Twitter post (140 characters maximum) and still have room for more. What makes these sentences powerful is the intense emotion. The people, ideas and things you care deeply about make excellent starting points for your journal writing.

Something else that makes sentences strong is verbs—action words. *Jump, write, think, plan, hug, draw, love* are all action words. They make your sentences speed along the page. When you stuff your sentence with verbs, your sentences crackle with action and interest.

Notice the difference in these two sentences:

Keeping a journal is a good way to make sense of your life.

Journaling tracks your life.

The first uses "journal" as a thing, and the second uses "journaling" as an action word. Maybe you don't like the word "journaling" because it changed a thing into an action. Do you keep verbs and nouns carefully separated? Thank you. I'm right there with you. Make an exception for your life; your whole life is action—acting and living out loud—so let journaling be part of that action.

Here are some other journal entries that are just one sentence long, but carry information, emotion and memories:

"Last night I dreamed I danced again, not ballet, but a wild, earthy, from-the-gut stomp."

"Her power over me vanished when I could see her as a drained old woman, no longer angry, just forgetful."

"It was my next life, and I was a cat, snoozing in the sun, dreaming of chasing birds."

Prompts for
One-Sentence Journaling

_____*pushed my buttons today when s/he* _____*.*

If I had a do-over for one hour of today, here's what I would do:

I learned something important about myself today:

If my life today had a headline, it would be_____ _____*.*

_____ *is angry with me. Here's why:*

The best thing that happened today is_____ _____*.*

Hanging Out With Haiku

Poetry is a touchy subject for journaling. Even touchier than drawing. If you have mixed feelings about reading poetry or writing poetry, you might love *haiku*—the Japanese art form. It solves a lot of poetry problems—like time and rhyme—and gives you good results. And it can be easy if you give yourself permission. Try it; see what happens. (This might be a good time to use the permission slip from earlier in the book.)

Sure, you can overload haiku with rules, but by now you know that's not my style. Let's take a look at the basic rules; then you can decide how much you want to use and how much to ignore.

A haiku has three lines. The first line has five syllables. The second line has seven syllables. The last line has five syllables. The poems often have a reference to nature or a season, generally through a metaphor. That's it. You can make it harder, but starting simply and finding yourself enjoying something enough to explore it more is a gentle way to learn.

The recognized Japanese master of early haiku is Matsuo Munefusa, known as Basho. Here is an example of his work. The rule for syllables was lost during the translation, though it applied to the original version in Japanese.

Clouds appear
and bring to men a chance to rest
from looking at the moon.
—Basho

When haiku modernized, and came to the West, writers often dropped the seasonal theme and focused on emotion.

Haikus can pin down your emotion, a memory, a moment—anything that flashes in your day. Your haiku doesn't have to inspire universal meaning, just make sense to you. Here are some examples I wrote:

My job. Fear. Anger
Sunday night, tossing in bed.
Why do I work there?

Cooking dinner—soup.
Feeding souls gathered around
My table, smiling.

Easing Into Haiku

- *Think of a big topic or emotion, then whittle it down. Break your experience into one thought, action or emotion.*
- *Take the time to choose words that describe your feelings precisely. Did you smile or grin? Cry or sob?*
- *Choose the one small moment that describes your whole day. Pare it down to the heart of the experience.*

Once you have a haiku, make it important on your raw-art journal page. You can do this in several ways—frame the whole haiku or focus on the heart-word of the haiku. If you focus on the heart-word of the haiku, you can stamp the word, write it and color it in, or write the word in big letters to fill in. Or write the word first, then fill in the space around it, like the exercise Light Up a Single Word that we just worked through from page 40.

Haiku-in-the-Box

You can use the arc-triangle-rectangle framing method (see page 41) for framing an entire haiku, instead of just a single word. Enjoy the repetition of the pattern while your mind drifts over the meaning of the haiku, or just take pleasure in doing this work that will have a satisfying outcome no matter how you design it.

Horizon sunset
Orange washes twilight stars
first pale, then sharp, bright.

(see page 41)

What You Need

fresh journal page or piece of paper

2B pencil

writing implement of your choice

colored pens, pencils or markers

1 Write the haiku on a journal page in regular handwriting or calligraphy—using whatever writing implement you like. It doesn't have to be in the middle of a page; it might be much more interesting if you put it closer to the upper or lower corners. Freehand a rectangle around the haiku, leaving about ½" (13mm) of white space between the edge of the writing and the rectangle. The freehand rectangle will be imperfect, making it far more appealing than if it were hard-edged and straight.

Haiku Framing Variations

1. Make the frame first, without writing the haiku in it. Before adding color, scan it into your computer. You can now adjust the size, print it out for any other haiku and use different colors to suit your mood.

2. Create the frame on a transparency, using inks or alcohol markers. Write the haiku on your journal page and layer the trimmed transparency over the page, securing it with rivets or decorative tape.

3. Print the haiku on the transparency, and trim it carefully, leaving an edge. Draw the frame on your journal page, and cut out the center of your rectangle. Attach the haiku from the back of the page, using glue or tape. Whatever you draw on the next page will show behind the transparent haiku, creating depth and adding color.

4. If you are using two or three colors, remember the "room rule:" Use the main color for the majority of the space (think of painting the walls of a room). Use the secondary color for a smaller space (think of the trim in a room), and the third color as an accent (like throw pillows.)

5. Use the word exercises from earlier in this chapter (such as Words as Tarot on page 38—don't forget to include the date) in these frames, instead of haiku.

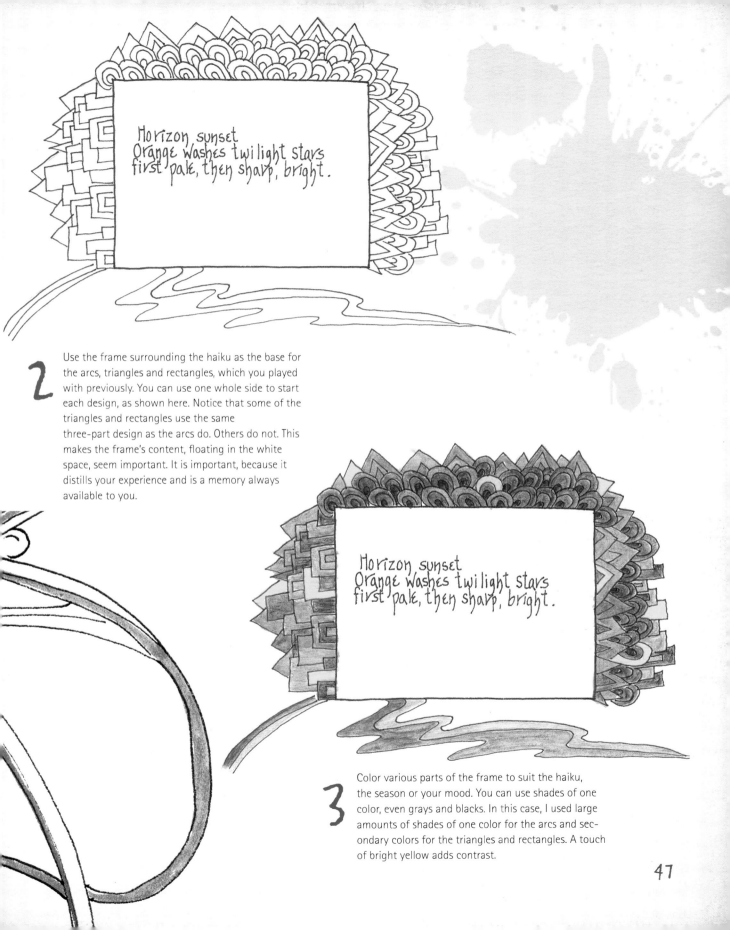

Horizon sunset
Orange washes twilight stars
first pale, then sharp, bright.

2 Use the frame surrounding the haiku as the base for the arcs, triangles and rectangles, which you played with previously. You can use one whole side to start each design, as shown here. Notice that some of the triangles and rectangles use the same three-part design as the arcs do. Others do not. This makes the frame's content, floating in the white space, seem important. It is important, because it distills your experience and is a memory always available to you.

Horizon sunset
Orange washes twilight stars
first pale, then sharp, bright.

3 Color various parts of the frame to suit the haiku, the season or your mood. You can use shades of one color, even grays and blacks. In this case, I used large amounts of shades of one color for the arcs and secondary colors for the triangles and rectangles. A touch of bright yellow adds contrast.

Haiku Gallery

Meditating on a garden hill I see
that the unvarnished railing has cracked.
A network of lines runs along the gray wood,
reminding me that beauty
and death are friends.
—Charles Brownson, Tempe, Arizona

Dreams to live—our own
our parents'—a lot to ask
Hard, all this dreaming.
—Marianne de Bliek, Amstelveen, The Netherlands

Licht bedingt Schatten
Ohne Freude kein Leiden
Leben bedingt Tod.

Translation:
Light begets shadow
No joy without suffering
Life begets death.
—H. Peter Clamann, Bern, Switzerland

Chasing dark spirit
Flames expose shifting shadows.
Ah, lumination.
—Bo Mackison, Madison, Wisconsin

Frosted sunflowers
Striped seeds, black and white, release.
Fall shrugs her shoulders.
—Bo Mackison, Madison, Wisconsin

The dog is barking
Will it never shut its mouth?
I wish they would move.
—Anita Veccia, Gilbert, Arizona

Perhaps I live my life
as I use my pen
gripping it tightly
bearing down
to press meaning from its tip
while others balance
the instrument lightly
and dance across the page.
—Carolyn Wyatt, Herndon, Virginia

Anger
I sit in anger
today roiling clouds, fire shroud
my quaking mountain.

No water will quench
the searing pain except to
rest in compassion.
—Carolyn Wyatt, Herndon, Virginia

Alive
I went to greet the sun today,
a thunder squall rolled through at dawn.
I knew the sun had risen, though
I did not see it arrive.
Ever brightening blue skies chased
the thunder clouds eastward,
it was a great day to be alive.
—Donald Slattery, Haymarket, Virginia

49

Keeping Secrets Secret

To keep a meaningful journal, you need to feel comfortable and believe your secrecy is respected. Do you want your writing to be yours to process, but kept private from everyone—even yourself—years from now? In that case, choose to hide your words in your journal in such a way that they make a good design or background, but are covered with other journal entries. If you want to make your journal entries hard for anyone to figure out, but easy for you to remember years from now, you can choose a way to hide your words that isn't obvious, but that can be reversed. Both ways have advantages and disadvantages.

The advantage of hiding it all is that you won't keep warming up emotions that are better left in the past. By using one of the Hiding in Plain Sight techniques, you can write down things that you want to release, to let go of, to put behind you for good.

The disadvantage of permanent hiding is that it is truly gone. You cannot predict today how you will feel years from now. Perhaps it's useful to know that you keep repeating the same choices, but in different ways. Those choices aren't always obvious while we are making them. Sometimes they need the passage of time to become clear.

The advantage of hiding techniques that are reversible—what I'll refer to as Just Plain Hiding—is that you can recall memories, lessons learned, choices that changed how your life unfolded. It can be a big advantage to know what it took to make positive change.

The disadvantage of reversible techniques is that you have to remember how to reverse them. You'll have to leave yourself instructions where you can find and remember them. What seems so clear today may become more difficult down the line.

The important part of journaling is that it is the real history of life—not just yours, but other people's lives. History books focus on the changing power of war. Journals focus on the changing power of community, art, culture, family. You can contribute to the way the world is remembered.

Hiding in Plain Sight

How important is your privacy? If you hide your thoughts permanently, you'll be able to get your emotions out and think through your choices today, but you won't be able to know how you came to your conclusions, and you may not remember exactly what it was that you were thinking or feeling when you go back through your journal later. If privacy is most important to you, the "forever hidden" ideas on the next several pages are useful tools to try.

52

Secrets' Flip Side

Every time I teach a raw-art journaling class, someone worries about revealing secrets in a journal.

"What if someone finds my journal and reads it?" a woman asks. (Men don't ask this question often.)

"Is it one thing you want to keep private, or is the whole idea about someone reading your thoughts creepy to you?" I'll ask.

"I just don't want anyone sitting around after I'm gone, poking through my things. And I really don't want my kids finding out the stuff I wrote in the journal," is the answer I hear most often.

If you use social networking sites like Facebook, LinkedIn or Twitter, your life is probably not as private as you think. All of your remarks, hints and comments are read by the people you consciously shared them with, but also by those same people who then went on to share your ideas with others. It's as true in day-to-day living as it is on the Internet: If you really want to keep a secret, keep it to yourself. Nothing else is guaranteed.

I'd rather have my relatives know about me than marketers and spammers who troll the Internet looking for information. In real life, I tell my classes the story of finding my mother's love letters to my father after both had died and discovering a completely different mother than the stern, talented, needle-arts disciplinarian I had known. In the letters, I found a hopeful, funny, loving woman and much about her life that was completely new to me. She had kept it hidden and would not have wanted me to see it in her lifetime, but I am so grateful that I now know more about her as a young wife and mother. My father's nature journals and sketches, which show the difference in his vision when he got his glasses as a youngster, as well as the changing landscapes of his life, are among my most treasured possessions. Your children will have different views as they grow up and have adult lives of their own. Once you are gone, is there really a reason to hide who you were and all the circumstances that created you? People gain different perspectives. Do you really need to control your life after you are no longer living it?

Background Secrets: Writing to Forget

Many of our secrets are emotions we want to hide. One of the gifts of keeping a journal is that you can write to forget—what you put in a journal spills out of you, onto the page and out of your memory. These are excellent secrets to use as backgrounds for over-writing (adding new writing right *over* the top of the initial writing). Here are some suggestions for topics:

- **Get rid of your anger:** What makes you angry? How do you react to anger, and how do you get rid of it again? Do you feel better if you act out, or does that make you feel guilty?

- **Confront the bully:** When was the last time you read about or saw a bully? What memory of bullies in your life did that bring up? Be detailed. Write about the frustration as well as what you did. Then add a paragraph about how you would have liked that incident to end. You can end this in any fantasy way you want, from the bully melting to your reaction creating a change in the bully's life and heart.

- **Say what you mean:** Think back to the last disagreement you had with a loved one or friend. You may have backed off because you wanted to be liked. What would you have wanted to say or do, something that you would never do in real life? If this is not safe emotionally, think about the last time-wasting meeting in the office and how you would have ended all that senseless posturing.

- **Release dull or pesky thoughts:** If your gremlin has been noisy and complaining all day, group the thoughts together on one page.

What You Need

fresh journal page or paper that can stand up to a bit of water

watercolor pencils in various colors

clean water

watercolor brush, cotton swab or sponge makeup applicator

Every time I teach a raw art journaling class, some one worries about revealing secrets in a journal. "What if someone finds my journal and reads it?" a woman asks. (Men don't ask this question very often.)

"Is it one thing you want to keep private, or is the whole thing—the idea about someone reading your thoughts—creepy to you?" I'll ask. "I just don't want anyone sitting around after in gone, poking through my things. And I really don't want my kids finding out the stuff I wrote in my journal," is the answer I hear most often. If you use social networking sites, your life is probably not as private as you think. All the remarks, hints and comments are read by people you shared them with, but also

1 Write your thoughts down in watercolor pencils. You may want to try using one color per page or one per paragraph or perhaps one per sentence. Use colors that blend well, because that's exactly what you will do—blend it together. You can use any watercolor pencil, water-soluble crayon or graphite. Fill the page, changing pencils often if you want a mixed-color blend.

Every time I teach a class on raw art journaling, some one worries about revealing secrets in a journal

"What if some one finds my journal and reads it?" a woman asks. (Men don't ask this question very often.) "Is it one thing you want to keep private, or is the whole thing — the idea about some one reading your thoughts — creepy to you?" I'll ask. "I just don't want anyone sitting around after I'm gone, poking through my things. And I really don't want my ideas in front of my kids— I don't want them finding out what I write in my journal," is the answer I hear most often. If you use social net- working sites, your life is probably not as private as you think. All the remarks, all the hints you share with them, you are passing on to the

2 Use a wet watercolor brush, cotton swab or sponge makeup applicator and dab it over the letters to blend the colors. If you are using a brush, start with short, light strokes to blend the colors. If you are using a sponge, use blotting or light pouncing to keep the transparent color on the page, not your sponge. Leave some of the words and letters to create visual interest. Avoid scrubbing. Continue blending until the words are no longer clear and you have a good color mix to use as a background.

3 Once you have blurred the words enough, decide how much color you want on your background. For less color, use more water and lift off color by blotting and rinsing the sponge or brush. When you are happy with the result, let the page dry completely. This may take longer than you think. Don't place your journal in direct sun to dry it, as the colors may fade and the paper warp. You can use a hair dryer to speed the process along, but avoid heat guns held too close to the journal pages. Glues, waxed linen, beeswax and metal connectors react differently to the intense heat of a heat gun, and you don't want to damage previous pages for the sake of drying the current page. Once dry, the faded page is a perfect background for a regular journal entry—you write over your secrets, hiding them in plain sight.

Palimpsest

You are in good company if you use this method. It's called palimpsest and is an ancient method of over-writing. The Greeks scraped off layers of clay tablets and wrote over the original material. The Egyptians scrubbed papyrus scrolls with milk and oat bran to fade manuscripts so they could be overwritten. The fading didn't remove the writing entirely, so the first writing was done horizontally, and the second vertically, to make the most recent writing clearly visible.

Intense Color

I used Derwent Inktense watercolor pencils in this example because the bright colors make a good back-ground for later writing with blue or black ink. Inktense colors won't hold a point well—they are meant for color, not detail—so you might not like them if you tend to write small.

Using Your Computer as an Accomplice

Are you keeping your journals on your computer? It does help you write faster, but a raw-art journal helps you involve your hands, heart and spirit through meaningful art. I find raw art just isn't as satisfying on a keyboard. But you can use your keyboard for some of the writing in your raw-art journal. Crossing over from a computer-written to a handwritten journal can lead to interesting results, as the next three exercises will show.

Fading the Memory

Using any writing prompt that you like (see page 53 for suggestions if you feel stuck), compose your thoughts on the computer, instead of writing them by hand. If your journal page is smaller than the page you are going to print on, that's fine. You are creating a background, not a journal entry.

What You Need

computer and printer loaded with standard copy paper

pen you wish to overwrite with

scissors or paper cutter (optional)

glue or gel medium

your journal

I had rather have my relatives know about me than marketers or spammers who troll the internet looking for information about you. In real life, I tell my classes the story of finding my mother's love letters to my father after they both had died, and discovered a completely different mother than the stern, talented, needle arts disciplinarian I had known. In the letters, I found a hopeful, funny, loving woman and much about her life that was completely new to me.

Highlight the entire page and, using your computer's word formatting palette, select a pale color (choose a pale tint of a color that contrasts with the pen you'll use to write over the top of it—green, orange, brown). Change the typeface to something interesting and blow up or shrink the size of the type. If you love traditional black print on white paper, choose a 10 or 20 percent gray tint for printing. Once you've created an interesting background, print out your secret.

Tear the edges by hand, use decorative-edge scissors or trim them with a paper cutter. Complete your overwriting on the page and then glue it into your journal.

Turning the Tables on the Page

If you like using your computer but want something more visually interesting, you can make use of the palimpsest effect—the text lines on the printed piece will run vertically, forming pinstripes up and down the page, and you will write across them in horizontal lines.

I'd rather have my relatives know me from my writing than telemarketers and spammers who troll the internet looking for information about you.
In real life, I tell my classes the story of finding my mothers love letters to my father after both had died, and discovered a completely different mother than the stern, talented, needle-arts disciplinarian I had known.

I'd rather have my relatives know me from my writing than the tele marketers and spammers who troll the internet looking for information about you.
In real life, I tell my classes the story of finding my mothers love letters to my father after both had died, and discovering a completely different mother than the stern, talented needle-arts disciplinarian I had known.

If your handwriting is small and tidy, you'll get a grid effect. You can also increase the size, line spacing or typeface on the vertical print for a wallpaper effect.

What You Need

computer and printer loaded with standard copy paper

transparency paper (compatible with your printer)

pen you wish to overwrite with

scissors or paper cutter (optional)

glue or gel medium

your journal

photo corners (optional)

Want something more versatile than paper? Print your journal entry out on a transparency. Reduce the type, turn it into an interesting color, and run it through the printer twice—once normally, then by putting the already-printed transparency in with the bottom end first. The double printing makes it impossible to read but makes a good divider page. You can also fasten it to a page by trimming it to fit and then using photo corners.

Tangled Words

If your handwriting isn't wonderful, you are in luck. For this page, the worse your handwriting is, the more interesting the page. As someone who always wanted to master calligraphy but never could, I thought it was time to honor everyone with loopy, slanting-in-every-direction handwriting. I'm with you every day.

Transparency sheets for overhead projectors don't have a front or back (unlike transparency paper for your printer), so it doesn't matter what side you start on. Trim the transparency to the size of your journal page, or slightly smaller, if you want to attach it by photo corners or rivets.

What You Need

overhead projector transparency sheets (available from office supply stores)

poster pens (available in white, blue, yellow, red and black at office supply stores)

black paper

craft knife or paper trimmer

Using a writing prompt from page 44, use a white poster pen and big handwriting on your transparency sheet. Begin writing faster than you normally would. You don't want carefully formed letters—you want lots of loops and points. When you get to the bottom of the transparency, go back up to the top and continue with your same line of thought in the spaces between the lines. Don't worry about leaving a margin and don't hyphenate words. When you run out of space, simply continue the word on the next line.

When you are done on one side, turn the transparency over and write on the back as well. Write two or three layers on each side. If you see a space, write your next word in that space—it can go anywhere.

Try writing in more than one color on your transparency. If you like darker colors, use black and blue, one per side. This is effective over a white or cream page, and can also be used effectively with a gray or light blue paper backing the transparency.

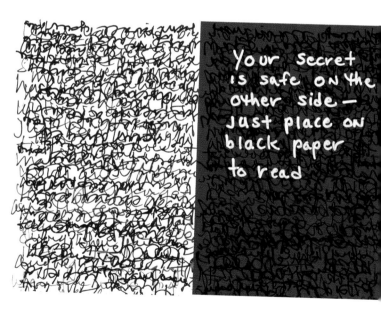

Your secret is safe on the other side — just place on black paper to read

You can use the back of a transparency to say something readable by choosing the right color background. This works particularly well for short phrases you want to highlight, like a quote or a prayer. Write on one side with a black poster pen, using the tangled-word method on one side of the transparency. When it's dry, write the quote on the reverse side, using a white pen. When backed with a white sheet, the quote will not show (effectively hiding your thoughts), but when backed by a black sheet, the quote shows clearly.

Just Plain Hiding

If you want to hide, but not obscure, your journal entries, there are many fun methods to try, including a few you may remember using from childhood—codes, secret languages or puzzles. To keep your secrets safe and hidden, but available to you later, you'll want techniques that still give you a journal with color and eye appeal. The exercises that follow fit the bill.

How Codes Got Started

Codes started about the same time as written language did. The study of codes is called cryptography from the Greek words kryptos (secret or hidden) and graphos (writing). Lysander of Sparta devised the first clearly recorded code. In 405 BCE, Lysander received a coded message written on the inside of his servant's belt. What looked like a long string of unrelated letters became a message when the belt was spiraled around a stick of a pre-chosen diameter. The letters lined up and could be read in a straight line down the stick. The message? Persia was about to attack. Lysander prevented the attack by sailing to Persia and defeating his enemy.

Code Talking

Remember secret messages written in code? You probably used a code to pass notes in class when you were in grade school. Those same codes and many more can be used just as easily today. A simple replacement code (substitute the letter A for the letter Z, B for Y and so on) keeps your secrets and lets you easily untangle it when you are ready. If you like symbols instead of letters, you'll like the frame code. I learned it years ago in Girl Scouts and loved using it as a design around my journal pages. It's easy to learn—you'll be able to use it without any studying!

What You Need

pen you enjoy writing with
your journal

Using this grid of letters, replace each letter with the format of lines that surround it on the chart.

AB	CD	EF
GH	IJ	KL
MN	OP	QR

ST
UV YZ
WX

Indicate that you are using the second letter in a pair by using a dot.
So the words 'code' and 'secret' would look like this.

Code = ⊔⊓⊡L

Secret = VL⊔⊦L⊻

If you have a knack for codes, this one looks exotic and is easy to learn. The solution grid is easy to remember; you could tuck it into a hidden pocket in your journal or write it on one page and glue the facing page to it. To keep the solution usable, glue the edges of the pages with glue dots only. You can easily pry them open, but it's unlikely someone else will look there first.

Woven Words

If you think writing in code might take too long to write all that you want to say, you could substitute some of the words to save time, but you might also want to hide your writing in a way that feels more artful. With this method, you can choose visually exciting and hidden. The best part about the woven journal page is that it doesn't require you to be fussy or exact. The shape is organic, so feel free to be wild! The less planned your cuts, the better the result.

What You Need

two sheets of paper, the size of your journal

1" (3cm) paintbrush

contrasting colors of acrylic paint

sponge

cutting mat

craft knife and scissors

poster-paint pen; ink and brush; or permanent marker

1 Using acrylic paint in a dark color, cover one piece of paper with a layer that is thick enough to hold brush marks. (I used a mix of Golden's Paynes Gray and Ultramarine Violet.) On a separate sheet (or a page torn out of the back of your journal), use a bright, contrasting color to cover the entire page. Next, sponge over the bright color with a slightly darker color. (I used Golden's Naples Yellow, let it dry, and then sponged Quinacridone Crimson over the yellow.) Let both pages dry completely. If the page feels cool to the touch, it's not dry yet.

61

3 Using a poster-paint pen, a brush dipped in ink or a Sharpie, write your secret on the light-colored page. Let the writing dry completely.

2 Slide a cutting mat under the dark-painted page in your journal. Using a craft knife, cut seven wavy lines on the page. Cut the lines so they don't line up precisely parallel with the spine or with one another. It's better to make them intentionally at an angle than worry that they won't be perfect.

Variation Possibilities

There are many variations on this technique. Create a stark, elegant, white-on-white look by not using paint at all. Use a light-colored gel pen to create an elegant look, or a heavy black pen for a graphic pattern.

If you never want to re-read what you wrote, you can use a sewing machine to stitch over the completed weaving. That will add another dimension. Choose your colors ahead of time to coordinate the page without making it too busy.

You can write on both sides of the cut strips. Because you write horizontally and cut vertically, and mix up the strips, no one will be able to read it. Both sides of the page will be designed at the same time.

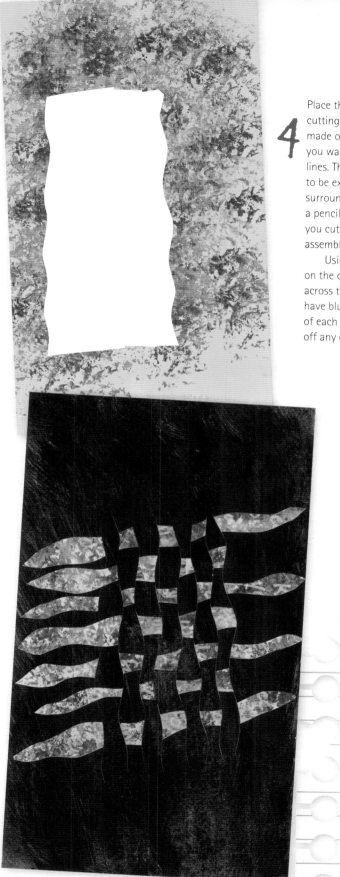

4 Place the lighter-colored page, writing side up, on a cutting mat, and make the same kind of wavy cuts you made on your journal page. Make vertical cuts because you want to cut through your writing, not along the lines. The cuts can be different widths; they don't have to be exactly alike. Make enough cuts so they completely surround the writing. Then turn the page over and, using a pencil, number each strip on the unpainted side. Once you cut the strips from the page, you will be able to re-assemble them in the right order to read your writing.

Using a craft knife, cut the strips of paper (while still on the cutting mat) from the page by cutting straight across the top and bottom of the vertical cuts. They will have blunt ends. Using a pair of scissors, trim the ends of each strip to give them a point. (Be careful not to trim off any of your writing.)

5 Weave the cut strips through the wavy cuts on the darker-painted page. You can weave them in any order. Snug them as close as they will slide. The cuts create an interesting visual pattern, but they also hold the strips in place so you don't need to glue them down. If you want to see what you wrote, slide the strips out, turn them unpainted side up, put them in numerical order, flip them over again and read your secret. While they are woven into your page, it is impossible to read what you wrote.

Working Directly on the Journal Page

You can work directly in your journal if you prefer. Slip parchment paper between the sheets you are painting. You will need to cut slits on the page in your journal (using a cutting mat under the page) and use a page outside your journal to create the weaving strips.

63

Words So Big They Disappear

This method can be used both ways—to hide your writing forever or to leave it readable. This method works with acrylic paints and inks, even watercolors. You will use an accordion journal, which is easy to make (see page 119), and you can create separate journals for different emotions by using coordinating colors of paper or ink. You can also tip one end of the accordion into your journal, creating a multipage foldout.

Your handwriting is art, even if people complain that it's hard to read. Leaving your mark on paper is an important activity—it identifies the paper as yours, it claims a space. Because your handwriting is artwork, use it by varying it. Do you always write small? It's time to write big. Have a bold hand? Make it *really* big. Use your writing as a design element. Writing big also feels like exaggerating the emotion in the words you are writing.

If you'd like a new prompt for this exercise, try using the following:
It's so unfair of *[name of person]* to say *[describe what was said]* when all I wanted was *[emotion or specific request]*.

What You Need

big piece of paper (or several smaller pieces connected by gluing or taping), about 12" x 22" (30cm x 56cm)

china marker

variety of writing instruments such as: gel pens, fiber-tip pens, charcoal sticks, poster-paint markers, broad-tipped markers or chisel-tipped markers

eraser, either kneaded or electric

kitchen timer

spray bottle of distilled water

acrylic paint and paintbrushes

India inks in various colors

1 Spread your unfolded paper out in front of you. Set a timer for three minutes. Using a white china marker, begin writing and push your hand to make big, bold strokes. You won't see the words as you write, but don't let this deter you. When you get to the end of the piece of paper, flip it over and write on the other side. When you reach the end again, return to the first side and keep writing, right over your original words. Keep doing this until the timer sounds and the page is filled with huge, overlapping words that create a tangle of lines as a background.

Spray one side of the paper with water. If you are using a sturdy paper, such as Velin Arches, you can dip the paper in water and shake off most of the water. The china marker acts as a resist.

Drip 3–5 drops of ink on one short edge of the unfolded paper. Pick up the short edge, so the ink runs into the water and blends with it. Don't try to control the flow, let it find its own way. Create pale background by spraying with more water. Create a darker background by not spraying the paper at all until the ink begins to soak into the paper, then spray gently to allow the ink to spread.

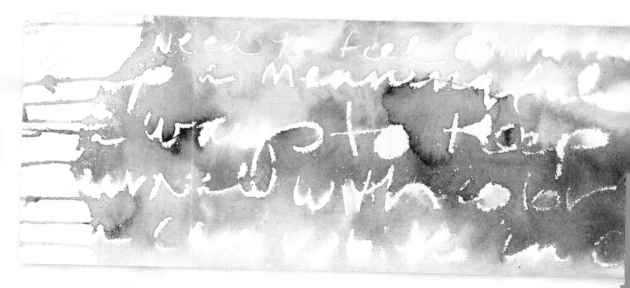

2 If you are using one color of ink on both sides of the paper, you can work on both sides at the same time. You can use coordinating ink colors—one on each side—or a blend of two different colors. Apply the darker ink color first and allow the paper to dry completely. Apply the lighter color in a second step. The first color will run, so work quickly.

3 If you want your writing to show less, use acrylic paint instead of ink. Use a light color to cover the words. (I used Titan Buff.) If you want words to stand out, use a stronger color of acrylic paint thinned with a little water or gel medium. (I used Quinacridone Crimson and Ultra Violet.)

Words are art all in their own right. Use them to set the tone for telling about a secret—and hiding the juicy parts! Maybe you want to paint over only a portion of the writing.

Variations on Big-Word Backgrounds

Rub liquid graphite (Derivan Liquid Pencil is one brand—use the rewettable formula) or finely ground graphite (General's Ground Graphite is a brand name available in most art supply stores) into the paper, and use a kneaded eraser or electric eraser to write with by lifting the graphite off the page.

You can use black paper and write with a gel pen or china marker.

Don't limit yourself to white paper. Use a variety of colors and write on them with fat markers, poster-paint markers or water-soluble crayons.

If you wrote very large and naturally write small, go back and write small in the loops of all the big writing as your overwriting technique.

65

Making Art of Your Words

 The last chapter was about hiding your words. While there may always be some words that you'll want to keep a secret, chances are that you'll also want to make others stand out and be seen. It's true that we often pour out our disappointments into our journals, but there is so much room left for victories, celebrations and joys. Don't whisper them in secret. Let those great events and successes take center stage—or page. Have you struggled and reached a goal? You'll want to remember that day. Have you finally understood something about yourself or the world around you? Time to shout it from your journal! Whether you got a promotion, marked a milestone birthday, found your soul mate or simply are feeling pure satisfaction, there are plenty of reasons to let your journal pages show your success and happiness. Highlighting the words that express these things is easily done by turning the words into art.

Fading Words into Focus

We've played a bit with the layering of colors; now it's time to explore fading colors for emphasis. Instead of writing in your journal with ink, try writing in bleach.

In this example, I'm celebrating overcoming a fear many of my coaching clients overcome—the fear of success. We plan for failure; we figure out how to soften the blow and set up a Plan B in case our success doesn't come. We seldom plan for success far beyond our wildest dreams. We even say, "I don't want to jinx it." Really? How is preparing for and planning something jinxing it? If you can't imagine it, you can't work toward it. No wonder so few people recognize success when it sits down next to them. They can only see it from afar, disappearing over the horizon. So the word I'm using is "Fear," because in the next step I write over my fear.

What You Need

newspaper to protect your writing surface

household bleach

India inks

colored paper—not just black, but purple, gray, blue or ta

interesting writing tools—sticks, tongue depressors, cotto swabs, small watercolor brushes, calligraphy pens, sign-writing pens (called automatic pens), the plastic part of a foam brush after you pull off the foam

gloves (optional)

glass or stainless steel bowl

1 Place a sheet of newspaper onto your work surface. Household bleach needs some precaution: Work in a ventilated space, and wear gloves if you have sensitive skin. Pour about 1/2 cup of full-strength bleach into a small, deep, nonreactive (glass or stainless steel) bowl. A deep bowl makes it easier to dip your brush or pen, and bleach evaporates more quickly in a shallow bowl.

Dip a writing instrument into the bleach solution and write the word you want to use in big letters across a sheet of colored paper. Big letters are easier than small letters at first. As you write, first the page will merely appear wet and dark, but then over several minutes, it will gradually fade.

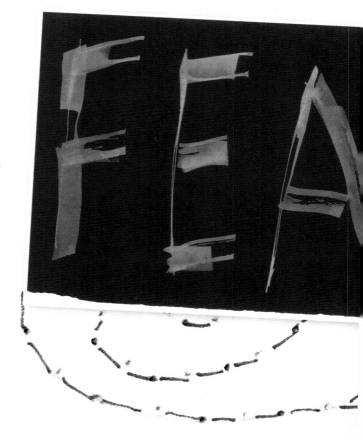

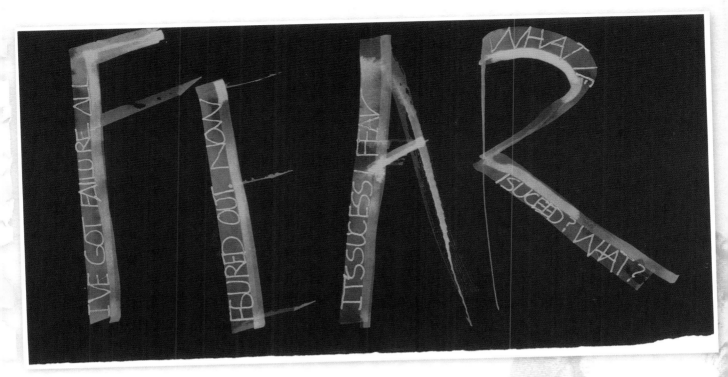

2 While the bleach is still damp and active, add some overwriting using a brush or automatic pen and India inks. In the example here, I filled in more spaces using long, smooth strokes of an automatic pen—a calligraphy pen with a broad, flat, metal tip. When the bleach was dry, I wrote on the inside of the bleach lines with a gold gel pen. The gel pen writing says, "I've got failure all figured out. Now it's success I fear. What if I succeed? What?"

Pen Pointers for Fading Words

Write the first letter of your message in large bleach letters, then tuck the rest of the word in the letter outline.

Write inside the bleach lines with colored pencil in the same shade as the paper to hide the writing more.

Use stronger or weaker bleach solutions.

69

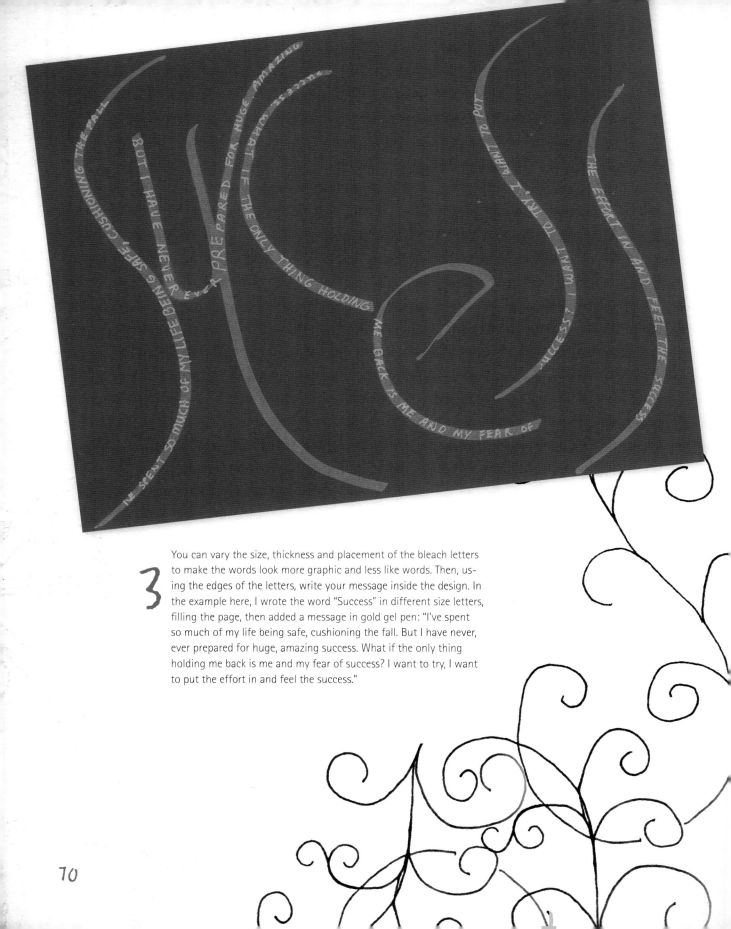

You can vary the size, thickness and placement of the bleach letters to make the words look more graphic and less like words. Then, using the edges of the letters, write your message inside the design. In the example here, I wrote the word "Success" in different size letters, filling the page, then added a message in gold gel pen: "I've spent so much of my life being safe, cushioning the fall. But I have never, ever prepared for huge, amazing success. What if the only thing holding me back is me and my fear of success? I want to try, I want to put the effort in and feel the success."

Pouring Emotion Into Lines

What made me fall in love with raw art was the freedom from needing too much to work with. Pack some paper or an index card, a pencil, an eraser, an ink pen and you are set. If you feel giddy, add a pencil sharpener, a different width pen and a journal with thick heavy paper; you're good to go. Save the painted pages for days in the studio, when you have supplies at hand.

Think you need color to express emotion? Well, color is a good way to express a dark mood or a bright feeling. But you can express emotions in many ways—in your choice of words, in the straightness and thickness of a line, in the kind of loops and lines you use. Remember the word "Joy" from earlier (page 40)? It looked and felt joyful, even before you added color.

Another wonderful thing about raw art is that the repetitive process is soothing. Doing raw art calms you down. The rhythm of raw art keeps your brain from running around in circles. It sits your gremlin down and gives it something to do besides make you angry, frustrated or sad. And in that deep peace, in that silence that is not echoing and frantic, you can actually think. Feel. Be. Sounds like a big order for just paper and pen. Well, once you add your thoughts and emotions, the circle closes, and you have artful lines full of expression.

Confetti Lines

Take a look at this simple design—draw some simple wavy lines, letting them cross in a few places. The trick here is not to try to design something, but to let lines flow in a slow, easy way.

What You Need

your journal

pen you like to doodle with

1 Try drawing the lines vertically, and they look formal and long and flowing. Draw them on the top of the page, and they look like a letterhead—representing you in a fresh way. Put them on the bottom of the page, and it looks like a lighthearted landscape. Placement makes a difference. Try the lines in different thicknesses, too. See how thin lines seem to take up less space. Try mixing some thin lines with thick lines to see if it feels more like how you feel.

Add Color to Confetti Lines

Use an italic pen to draw the lines—the thin and thick parts will give it a 3-dimensional look.

Fill in the geometrics with metallic or sparkly gel pens for a cheery look.

Go over the top by using a fine-tipped glue bottle and mirco-glitter for an extravagant look.

2 When you have moved the lines around on a page, try adding a bit more design. Draw a small triangle, circle or diamond where the lines cross. See how it changes the mood from serene and simple to fun and easy? Because you are adding the geometric pattern as a last step and the crossed lines show, fill in the geometrics with ink. Now it looks a bit more severe. Good for serious thoughts.

3 Try using a pencil to draw the lines. This lets you erase some of them if they seem too busy or crowded. Add small geometric elements and erase the lines that are inside the figures. Ink over the lines and figures, then use bright colors to fill in the shapes. Choose a color for each shape, or use bright colors on one end of the page and darker colors at the other end. You'll be surprised at how a little bit of color adds a lot of feeling. Once you have decided on how drawing the lines expresses your emotion, you have a tool handy. You can start with the lines and set the tone for your emotion, or write first and leave room for your emotions.

Drawing Patterns That Repeat

You already know a lot of repeating patterns in wall-papers, fabrics, textiles and in more common objects—paving stones, brick walls, the weaving in baskets and the holes in colanders. When you draw repetitive patterns, you automatically line certain parts up, keep similar elements the same size and fall into a com-fortable, relaxed feeling of noticing the page filling up.

Two repetitive patterns I love are Spirals and Lightning. When I first started doing spirals, I was inspired by the idea that we don't go in circles cre-atively, we keep stepping up a level—going in spirals, ever-growing, ever-exploring. I proudly showed my spirals to another artist, who said, "Oh, that's called 'desert rose', and it's an old pattern." I've since heard it called by many other names from people of different cultures. While I was surprised that someone else had "invented" it, I was also comforted that many other people recognized the growth pattern in the spiral.

your journal

pen you like to doodle with

1 You can make all the spirals go in one direction, or you can vary them. You can put them close together, overlapping them (and not drawing the parts that are hidden by other spirals), or keep them separate enough so each one stands alone. You can draw them in groups or in lines or in any other interesting pattern.

2 The Lightning lines can fill a page on their own, but I find them very expressive combined with the spirals. To make the lightning lines, simply draw straight lines of varying lengths, all parallel, with a fine pen (the lines look sharper with a fine pen). There are two end connections: One closes two lines of the same length with a gentle U-shaped line. The other connects lines of different lengths by connecting them with a swooping motion. If you look at the example, you can see that you can also connect short lines to long lines by a straight stroke, giving a precise separation.

To give the page texture, draw a section of lines going in one direction and another section in a different direction. Turn the page as you do this, so the lines are always drawn pulled toward you, giving you more control to where the lines stop. If you are working on paper that has a bit of tooth and with a metal-tipped pen (a fountain pen, rollerball or Micron), pulling the pen toward you keeps the tip running smoothly. Pushing it away from you can cause the tip to chatter over the fibers and break the line or spray ink droplets.

3 You can see in this example that combining these patterns has a lot of energy. It can look like clouds and lightning, like a bouquet of flowers or like sun behind clouds. The combination makes it versatile enough for you to use on many pages, from ambitious hopes to big inspiration. You can fill a page, leaving just a small section to write in, or you can cover about a third of the page with the pattern, leaving uneven edges with the lightning, and write on the rest of the page.

Over and Under: Complexity in Dimension

So far, we have used images without shadows or shading. It's time to add some depth by exploring the third dimension. Raw-art journal pages come from your imagination, so you aren't trying to copy something in front of you. This means you can't be wrong. Your imagination may show you patterns in three dimensions, and here is a way to make it easy to draw that way.

If you were filling a box with books, the first books you put in the box would go on the bottom. The next layer would go over those, and the last layer would appear on top. When you draw, the opposite is true. The first thing you draw will be on top, and the next will be below that.

What You Need

your journal

colored pencils or a pen

Tips for Lines

If it makes you more comfortable, draw in pencil first, so you can adjust where the lines cross or curve.

Use sepia ink for an older, manuscript look.

Draw in one color and write in another for more depth.

Use colored pens or glitter gel pens for a happy look and feeling on the page.

Look at the left side of the image. You'll see a solid red curve. It was the first one on the page. There are no others on top of it, so it is floating above all the other arcs. The next curve was the orange one with the chevron stripe. When I got to the red arc, I picked up the pencil and put it down again on the other side of the red curve. Next came the pink one. If you look carefully from bottom to top, you can see the order in which the arcs were drawn by which curves go over them. The last one drawn was the solid yellow one—it has no arcs under it. All the other curves go over it, making it the one on the very bottom and the last one to be put on the page.

Now that you understand how Over-and-Under works, you can use your imagination to create Free-Floating Bubbles, next.

Free-Floating Bubbles

Raw art allows your imagination to roam in complete freedom. This design is easy and flexible. No stencils, no templates. Put your hands to paper, and you can be as creative as your day demands.

1 Start by drawing a gently curving line across the entire page. Draw another line close to it so you have a ribbon. Draw freehand without using a template. The unevenness of the lines makes the drawing much more interesting than if you were exact. Now draw another line, parallel to the first two. You now have a ribbon with a center stripe. You can see an example of each of these ribbons at the top of the diagram. The thinner ribbon goes under the larger one. In the space between the ribbons, I drew a small circle. The small, curved mark on the right side of the circle makes you think of a ball or bubble, giving the circle another dimension—it's now a sphere.

Continue to draw lines with gentle slopes and waves. Notice that the lines in the ribbon under the space in the middle of the page all connect and then separate. This makes the ribbon look like it is turning.

2 Add as many lines and bubbles as you like—I like to make enough to make the page look interesting but not too busy. Leave some open spaces so you can write. Practice crossing under ribbons, making curves and placing the bubbles so that the lines go behind them.

With raw art, you can stop anytime you want, and then go back days or months later and add more if you want. Raw art is flexible and follows along with your own development and comfort.

In the example, I wrote in the lines because that looked interesting. But don't limit yourself. Write in the spaces you left, or even in the bubbles if you make them big enough.

The bubbles are perfect for writing the haiku you wrote earlier in the book. Try writing them in different places until you find a placement that matches your emotions.

Getting Edgy

So far in this section, you have worked a lot with curves, lines and circles. Those don't have to be your only choices. Other interesting design choices are squares and rectangles. You can mix and match different sizes to create a background.

What You Need

your journal

pen you like to doodle with

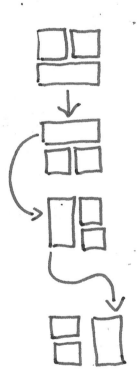

In addition to squares and rectangles, feel free to bring back some curves and circles to add a bit of softness to the design. However, if your emotion is edgy, stick with straight lines and hard edges. This is the time to link how you feel with what you write.

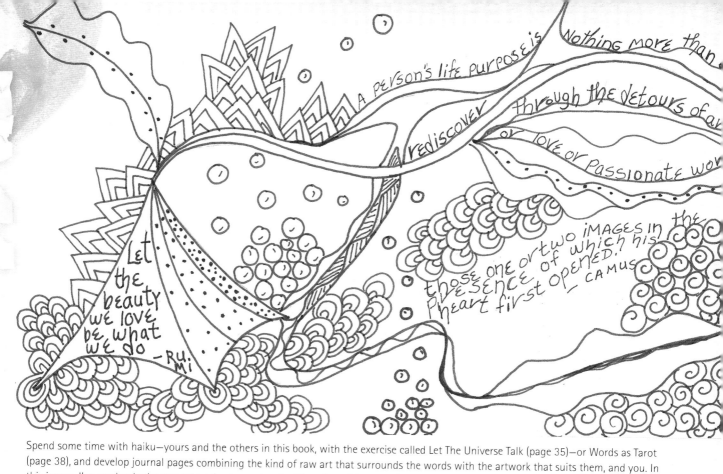

A person's life purpose is nothing more than rediscover through the detours of art or love or passionate work those one or two images in the presence of which his heart first opened. — CAMUS

Let the beauty we love be what we do — RUMI

Spend some time with haiku—yours and the others in this book, with the exercise called Let The Universe Talk (page 35)—or Words as Tarot (page 38), and develop journal pages combining the kind of raw art that surrounds the words with the artwork that suits them, and you. In this image, I've used only the raw art you've learned so far. There is nothing new, just combinations used in different ways.

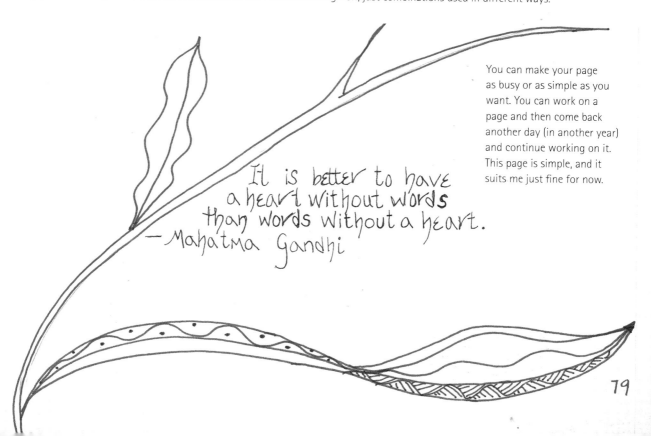

It is better to have a heart without words than words without a heart. — Mahatma Gandhi

You can make your page as busy or as simple as you want. You can work on a page and then come back another day (in another year) and continue working on it. This page is simple, and it suits me just fine for now.

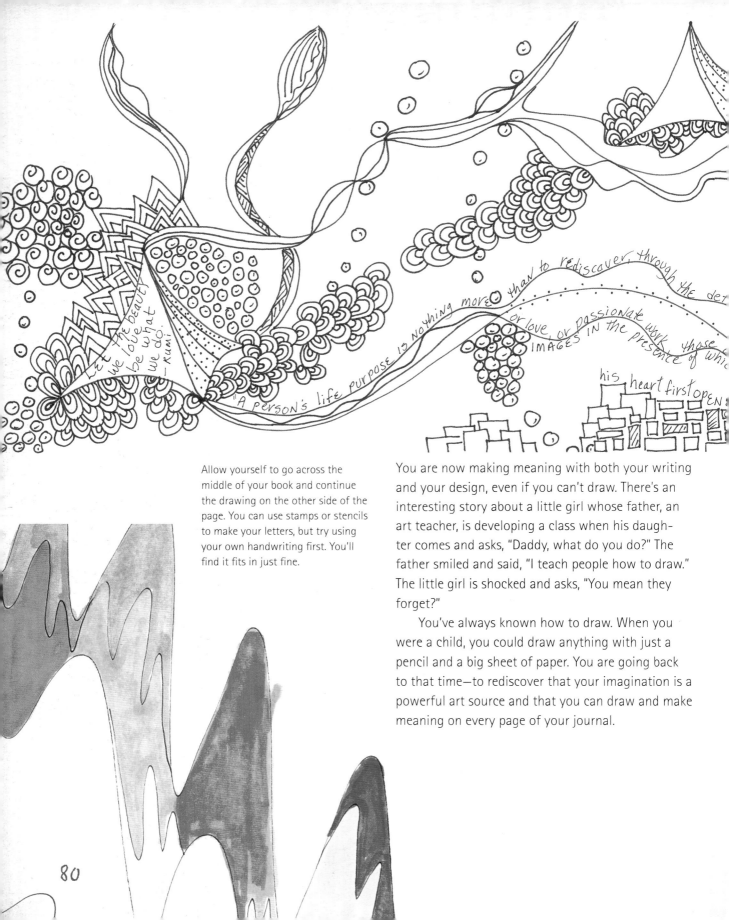

"A person's life purpose is nothing more than to rediscover, through the de[...] or love, or passionate work, those [...] IMAGES in the presence of whic[...] his heart first open[...]

Let the beauty we love be what we do. — Rumi.

Allow yourself to go across the middle of your book and continue the drawing on the other side of the page. You can use stamps or stencils to make your letters, but try using your own handwriting first. You'll find it fits in just fine.

You are now making meaning with both your writing and your design, even if you can't draw. There's an interesting story about a little girl whose father, an art teacher, is developing a class when his daughter comes and asks, "Daddy, what do you do?" The father smiled and said, "I teach people how to draw." The little girl is shocked and asks, "You mean they forget?"

You've always known how to draw. When you were a child, you could draw anything with just a pencil and a big sheet of paper. You are going back to that time—to rediscover that your imagination is a powerful art source and that you can draw and make meaning on every page of your journal.

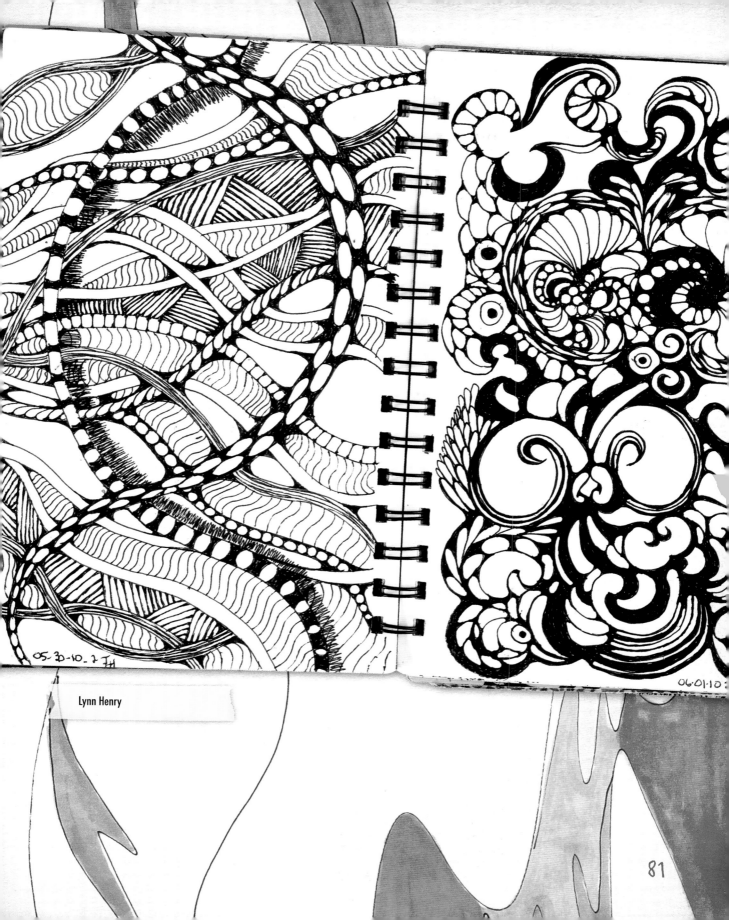

05-30-10-2 JH

06-01-10

The Accidental Landscape of Words

You've seen that journal writing that goes between two wavy lines? I think it's Teesha Moore's original idea, although now it appears in almost all art journals. What makes this writing work so well? Two things. First, it doesn't require calligraphy skills. It encourages you to use your own handwriting. Second, the rises and falls create an emotional and visual landscape on a page that reveals you as a writer—you express your emotions in the size and shape of the letters. You also understand what's going on in your head and heart by looking at what you've written and how you've put it on the page. Nothing is accidental. The more you free yourself, the more you get in touch with who you are and why you are here (in your studio, on the earth—it's all the same reason).

Calligraphy is beautiful, an artful pursuit, but out of the realm of experience for many of us. It requires precision and practice to become really good at it. All of that is understandable—practice is routine in all accomplishment—but a journal is the place to be free and imperfect. Your journal is the place where being "you" is enough. Your handwriting. Your marks. Your design. It's all good.

"The landscape of your journal" is an idea I've played with for years, after spending most of my life writing tidy, but slightly uneven, lines on unlined pages. (I've always preferred unlined journal pages.) So in this chapter we'll explore lines of words and lines as designs. I want to show you how your emotions can color a landscape and how you might go about crafting your landscapes on a page.

If you give yourself permission to write what needs to be said and give your hands permission to move across the page intuitively, you will find new worlds to discover and explore.

Word Oasis

The first "landscape" to try is simply confining words to one part of the page—like an oasis in a desert. If you look at illuminated manuscripts that monks copied and decorated with color and gold leaf, you'll notice that the manuscripts have one powerful image per page and big margins. So for this exercise confine your writing to one rectangle somewhere in the center of the page.

The words or design you decide to put in the space is given more importance when you leave the rest of the page deliberately empty. "White space"— the part of the page that doesn't have writing or illustration—creates emphasis.

Many art journalers start by "making the white page go away" by painting a background or collaging over the page, but that white space is valuable. It is important in the same way "personal space" is important around us. It creates a calm space, a place for our words to breathe. That doesn't mean you should stop painting backgrounds; it just means you have another choice. Sometimes busy is good, sometimes calm is good. Having choices makes your journal more valuable to you. You'll reach for it more often if you feel comfortable using it when you are happy or thoughtful or sad. Here are two exercises for you to try: one leaves more of the paper white, and one adds a spray of color for interest, while still maintaining a sense of white space.

Limiting the space on the page helps make the page seem less scary, and that makes you feel more confident, especially if the page is blank.

What You Need

your journal or blank paper

small scrap of cardboard

ink in a spray bottle

favorite writing or mark-making tools

1 Try putting down a rectangle cut out of cardboard onto your page and spray ink over it and the paper so when you remove the rectangle the writing space is negative space.

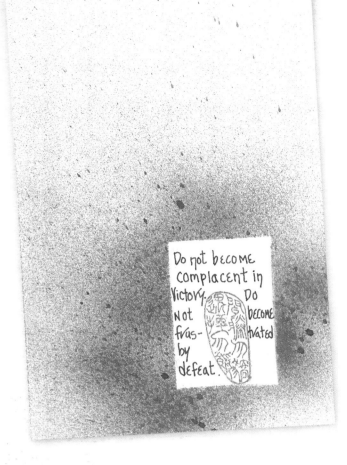

Do not become
complacent in
victory. Do
Not become
frus- trated
by
defeat.

1 Write something in the space. The Chinese chop in the space is written in ancient Chinese—it says, "Do not become complacent in victory. Do not become frustrated by defeat." It's one of my favorite sayings. It looks important put into a small space with the rest of the page ink spattered.

% Do not become complacent in victory. Do not become frustrated by de-feat. ◎ Do not become complacent in victory. Do not become frustra placent in victory. %

2 Now, on a new page, try writing just around the edge of the page. Keep turning the page as you write. Add some wiggly lines or dots between the words. Or, since it is your journal, simply stop writing when the design is complete. All those decisions are "allowed" when you use writing as design. When the center is empty, how does the page look different than if the center is filled? Try writing both in the center and around the edge. Now what happens? Do you like it? Try it with different colors or try mixing block printing and writing.

Moving to the Middle

Now that you've mapped out different parts of the page and claimed them, let's explore the landscape of the middle of the page. This can seem like a big and daunting area.

If you feel jumpy and edgy, not quite settled, try breaking up the page by creating a simple landscape across it.

1 Use simple lines to create a horizon with hills (or mountains). Stay away from the dead-on center of the page—that can make the page look boring. Keep this horizon line in the top third or the bottom third of the page.

2 Add some more mountains that create depth. Here they are done in a lighter shade so you can see what came first and what was second. But making the second line lighter also gives you the feeling that the second line is farther away. Add squiggles that indicate a road or river connecting the background to the foreground. You are creating your own idea of a landscape, not a photographic one. Humans need to see only 30 percent of an image before they recognize what it is. Aim for just enough detail to give your imagination permission to run around freely, not enough to make your imagination sit down and draw. Remember, you don't need to know how to draw for raw-art journaling. You already know everything you need to know—the contents of your heart.

What nature creates has eternity in it
—I.B. Singer

3 Now that you have the few lines down that create a landscape, decide what you want to add as words. Add words before color so you can decide what color will work with the words.

Confined Landscape Spaces

Just because you are drawing doesn't mean you have to fill the page. Leaving spaces empty says as much as filling them up. Use the technique of creating a small space on the page and put your landscape in a rectangle, then write around the edge of the small space. Try a spiral. If you have a lot to say, start at the upper left-hand corner of the page and spiral inward. Again, you don't need to fill the page. Three spiral lines of handwriting surrounding a personal landscape makes a meaningful page.

Another way to use lines to your advantage is to create a grid on your page and work within the lines in unusual ways. Three-column pages are attractive and easy if your page is taller than it is wide. Try dividing the page with two evenly spaced vertical lines, creating three columns. You do not need to be exact, but a ruler helps in making the lines straight. You can work within the three columns, perhaps writing words vertically along the lines. Once you've tried that, take it one step further and divide the page horizontally into thirds, with two horizontal lines in addition to the two vertical lines, to create a nine-section grid. If you are comfortable just eyeing this—great! But if the thought of working in thirds causes anxiety, here is a great trick. I learned this trick from Michelle Ward's website GPP Street Team (Crusade 41, July 2010). It lets you make an accurate grid on any sheet of paper.

What You Need

your journal or blank paper

ruler

T-square or right-angle triangle (optional)

pencil

Where to Find the Right Words to Add

Writing your own words, like you did earlier in this book, is wonderful for your soul. But there are days when you can't write. You want someone else to say it for you. Finding the right phrase, sentence, poem or fragment can be as surprising as finding an opal in your breakfast granola.

Sure, you can Google "poems" or "quotes." It's great if you are looking for something you already know. But don't deprive yourself of the joy of discovery. Start with the usual places—books you already have. Then expand to the library. Copy poems or paragraphs from books as you browse; don't think you'll remember where that page was. Another wonderful place to look is used bookstores. If the store is a little untidy and you find piles of unsorted books, all the better. Look for books of poetry, particularly from authors you don't know. Self-published or small-press collections of unknown authors are hidden treasures. Page through the books looking for a word or a line that speaks to you.

Find a phrase or a short poem you love and write it into the landscape. Try writing it on one side of the page. Try it again, on a new page, following the line of the mountains (see page 85). Try it again on the river road that runs to the front of the image. Each time it will look different. Each time it will mean something different to you.

To create an even grid, lay a ruler diagonally across the page so one edge of the ruler lines up with the edge of the paper at the 0 and the other end at a number that divides well by 3 (you are making a grid that's 3 columns wide by 3 columns long). Let's say on the longer direction of the paper, you use 6" (15cm). So your ruler crosses the page at 0 and 6" (15cm). If you divide 6 by 3 you get 2, so put a mark at the 2" (5cm) spot. You can see the example on the dark line in the illustration. Now turn the ruler the other way (the red line) and repeat. Create horizontal lines through those marks. (A T-square ruler or a right-angle triangle helps and you won't need to measure again.)

For the lines that will cross the ones you just drew, repeat the process. Use 0 and 6 as the numbers on the ruler again, even though the page is narrower this way. Put the mark at 2 again, turn the ruler, repeat the mark at 2" (5cm), and draw the lines. Easy peasy! You have a 9-space grid.

Now that you have the grid, fill it in interesting ways. Draw your landscape in one space and fill the others with small writing. Use a prompt from earlier sections of this book, or simply answer the question: "How do I feel when I work in small spaces?"

Draw the same landscape in each square, altering one detail. For example, draw a landscape in the first square. In the next one, add a sun peeking out. In the third, make the sun show a bit more. By the last one, the sun is the dominant element.

You don't have to stick to landscapes in the grid. Here are some other ideas:

- Use gel pens to write and Pitt pens for the design. Then do it the other way around.

- Fill all the spaces with a different design.

- Choose a word with nine letters or fewer. Print a big letter in each space. Short word? Use every other space and draw in the others.

Emotions on the Grid

Knowing your daily emotional range is a useful tool to discover what makes you happy, stressed or calm. You can use grids to list your emotions in the course of a day, or the ones you have felt most often this week. Noticing your dominant mood gives you clues to the rise and fall of your emotional landscape.

What You Need

your journal

pencil and ruler (if you want to create a grid in the way I suggested on the previous page)

favorite pen for writing words

colored pencils

optional: gel pens, fabric or paper scraps

Write one emotion in each space. Use a big range but use YOUR emotions—thoughtful, dreamy, unfocused, cranky, content, at peace, seeking, hopeful, wondering—for example. Look at one emotion word. Close your eyes and think about a time you felt that emotion strongly. What color comes to mind? Don't rush, don't text a friend for the answer. Just sit with your eyes closed until you know. Add that color to the space in some way. For example, write the word with a watercolor pencil and then wash over it. Or use gel pens to put dots of color in the space. Make the grid lines with pastels or chalk and rub over them before you fill them in. Choose a color for each word and add it in the space in some way.

Content

dreamy

thoughtful

cranky

at peace

seeking

focused

hopeful

wondering

You don't have to stick with traditional color-emotion associations. Blue doesn't have to be *sad* or green *envious*. It's your journal; you get to decide the ground rules. If you associate being thoughtful with blue and being cranky with pink, that's yours to treasure. Get in touch with the colors of *your* emotions.

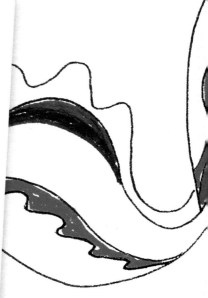

You can create grids in unusual ways, too. Using the idea of the grid, you can create a background (I used black) and cut out shapes from decorative papers or papers you've made for other projects. You can write on them or leave them plain. Arrange the pieces on the page in a pattern that creates a grid. In the illustration here, I used the 3-column by 3-row grid from before.

Rather than place one piece of paper in each box, I created a pattern with eight pieces—three circles, a square and several rectangles. Being careful to place pieces in the grid areas, but allowing some to cross into two areas, the piece's composition uses the grid, but not in an obvious way. I could have used rubber stamps to write the words, but using my own handwriting gave the piece a more organic feel. The red Chinese-writing square says "ink spirit," which I added in handwriting along one edge. Writing words by hand allows you to spend time with your work in a very heartfelt way. In this piece, "ink spirit" indicates the power of words, whether written, spoken or read. The soft, warm watercolors add meaning to "inspiration" and "dream," both true ink spirits.

Grid Work

When working with grids, the place of most interest is where the grid lines intersect. If you are using squares or rectangles, it makes it easier to line up the pieces by one of their edges. For example, if you are using different size rectangles, you can line up pieces so they all touch an imaginary line across their tops. You can use bottoms or sides as well.

Vanishing Landscapes

Sometimes what is left unsaid is more powerful than what is said. If you have always thought that what you put in your journal must be something added—you are right, it is what most people do. You can also take away—by cutting part of the page. This doesn't damage the page; it creates a new shape and a way to think about what is there and what is clearly missing.

When you are working on what you see and what you don't, you create in layers—layers of paper, layers of color and layers of meaning. You can add to the layers, remove them or cut through them. By cutting through what stands in your way, both metaphorically and literally, you create a view of the other side. Keep the reader's focus on the whole, or a part, or even a mysterious portion you keep hidden. This focus is particularly useful in writing memoirs, when you want to write the story the way you experienced it, from your perspective. Take a look at the waves on the next page to get started.

TravelinG USED to be exciting for me — I lov

were New or different.

Puffy comforter, I had a strange dream. It

least SEN

IN the hotel, too. IN the SAME room.

Words in Waves

There is a shape I use over and over again in my journals. It's an uneven, undulating wavy shape. I first saw it when I was four or five, learning to swim. It is the shape of sunlight in a swimming pool. If you look back to page 63, the section on weaving to hide your words, you will recognize the cutout shape.

You can use any color combination—high contrast or one palette of tones. The curves also look interesting cut out of white paper and glued onto a white page. Tone on tone can be sophisticated, as can shades of the same color, going from light to dark.

What You Need

background sheet and a sheet to cut waves from
(The background sheet may be a page in your journal.)

craft knife and cutting mat

pens to write with

acrylic or watercolor paint

paintbrush

scissors

glue

To create a landscape, first choose your color palette. Because you are working with a background and a foreground that is made up of parts, you have a lot of flexibility. You can shade both the background and the strips, but plan out the whole look first, before you start painting.

1 Using acrylic or watercolors, paint the page you plan on using for the waves first. Put it aside to dry completely.

2 Paint the background page next. Put it aside to dry.

3 When the wave page is completely dry, cut the waves by using a craft knife and freehanding wavy lines from the top to the bottom of the page. This creates the easiest movement. Then cut out the waves by using scissors to clip them off the page, from right to left. Use the scissors to create points on the blunt-cut wavy strips. (See page 63 for an example.)

4 Arrange the strips on the dry background page in the pattern you want. Experiment with short and long strips and spacing or overlapping them.

5 When you have the pattern you want, glue the strips down. Let them dry completely.

6 Once the strips are dry, you can write on the strips. Saving the writing for last allows you more control over the design. You can also write along the curves more easily by rotating the page with everything glued down and dry.

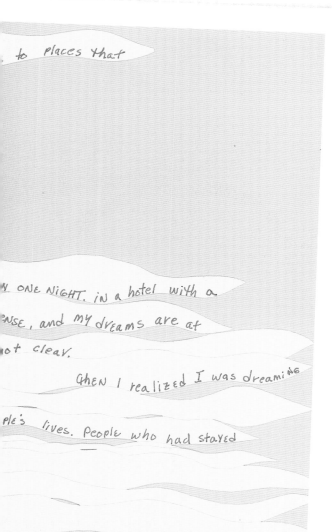

to places that

N ONE NIGHT, in a hotel with a
NSE, and my dreams are at
ot clear.

Ghen I realized I was dreaming

ple's lives. People who had stayed

The Open Window

You've already seen how wonderful it is to confine your writing or drawing to a small piece of the page. Now you can combine that technique with this one and create an open window, or an abstract shape that folds back and reveals something else. This following exercise is just one example of a creative way to incorporate a window into a page.

What You Need

your journal

small cutting mat or scrap of matboard to cut on

craft knife

two shades of paper, different from your journal page

glue

colored pens (optional)

collage images (optional)

1 Begin by putting the cutting mat beneath your page and using a craft knife to cut out a triangle shape. Cut that shape in half and glue one half on each side of the cutout. (Here I accented the glued-on pieces with yellow to help them stand out.) Cut out two more triangles the same size as the first cutout shape—in this case, I created a cream one and a blue one. Glue one to the back of the page (here, the blue one), rotating it so when you're looking at it glued down, it points left. Glue the other triangle (here, cream) to the next page, rotated in the opposite direction. When this page is turned, the viewer expects to find a cream-and-blue triangle, but that isn't what is seen; there is more here—sort of a journal-design joke.

Practical **expertise** being an artist is a life force, not a day job.

Now try cutting a thin, horizontal slot almost all the way across the page. Cut the corners carefully to avoid tearing the page. Trace a light line around the shape of the hole and use it as your small space to draw or write in. You can also play a verbal/visual hide-and-seek. Write a question or begin a thought near the top of the page with the slot you cut. Begin the answer on the next page so that the first few words can be read through the slot, but not fully understood until the page is turned. You can use one of these starters:

- If I disappeared, I would . . .

- What no one knows about me is . . .

- When I was a kid and wanted to hide, I would . . .

- The best thing I saw today was . . .

2 What you see instead, when you turn the page, is a spread containing the triangle cut out from the previous page, a small collage that isn't visible from the cover page at all and the other triangle on the opposite page. You can leave the page the way it is or come back another day and add more writing or design. The Bohemian-Austrian poet Rainer Maria Rilke said, "No feeling is final."

The Revealing Door

What hides behind swinging doors is always intriguing. It's easy to create a door in your journal page to reveal a surprise. The door you create can be any shape. Start with something simple—a triangle or rectangle. Using the flap effect (explained below) gives you the added thrill of having more to work with on the next page. Open the flap and you'll find additional words or design.

Now that you've tried a basic window shape, try cutting something more interesting—a curve, a moving shape. Keep the pieces you cut out so you can use them either singly or all together on another page. You can cut more than one shape out of a page, and use one shape—let's say a triangle—to cover another shape—let's say a circle. It doesn't have to cover the whole shape. Think about revealing and hiding and see where that idea takes you.

You can use a collage in combination with a reveal—a second lift-page that shows a small drawing, a photograph or another collage. This is particularly effective when you are working out what needs to be hidden and what needs to be revealed in your life. And yes, you can also use it just because it's fun. Journaling for fun is a wonderful way to spend creative time.

1 Begin by lightly ruling a rectangle on your page. Put the cutting mat under the page. Using a craft knife and a ruler, cut only along three sides of the rectangle, leaving the fourth (left) side uncut to act as the hinge side of the door. Using a ruler on the hinge side, fold the door open against the edge of the ruler to make sure it's straight. Slip a piece of scrap paper under the door flap and use alcohol markers to color the page. The paper scrap will protect the rest of the page from stray color marks. Wait a few minutes for the ink to dry, then "open" the door, put a fresh piece of scrap paper underneath it, and re-ink on the other side. Alcohol inks soak through, so coloring the patterns on both sides solves the problem of bleed-through.

What You Need

your journal

ruler

pencil

small cutting mat

craft knife

alcohol markers, such as Copic

white glue

colored paper

piece of paper with an interesting image

words cut from a magazine that explain the image

2 On the facing page (the one that comes after the door page), cut a rectangle twice the size of door to cover. In this case, cut a long piece of paper and fold it in half horizontally. Position the folded piece of paper over the door, then put glue on the back, and fold the journal page (to which the folded paper will stick) over, guaranteeing the position is right. Glue the words that hint at what is under the flap on the top of the flap.

3 Let the glue dry. Lift the flap and glue in the image or words you want to use. Now the only thing left to do is create "door stops"—pieces of paper that hold the flaps closed.

In this card, the blue triangle holds the front door flap in place, and the cream circle holds down the black fold-over. Both are design elements with a purpose.

When the door flap is lifted, a small, interesting part of your collage is revealed. Because the viewer is focusing on just one part, the collage becomes more important than the whole.

When the viewer turns the page, the circle indicates where to lift the black paper, revealing the image you drew. You can also use this technique to make interesting greeting cards with secret messages.

There are many variations of doors and windows you can create in your journal. You can use unusual papers to cover or back up the space left by cutting. Parchment, vellum, scrapbook papers and tissue all make interesting backs for the space. Use the tissue from old dress patterns, choosing pieces with instructions ("cut to edge" or "stitch to dart") or just the interesting lines. You can see strong colors and shapes through the tissue or deliberately blur the page behind.

Once you are comfortable cutting in your journal pages, try cutting a landscape. Try cutting just one of the mountain shapes or just the river shape. Be careful—don't cut too enthusiastically, or you will cut out the whole scene!

One of my favorite page embellishments is to draw the mountain page and then cut three wavy lines underneath it. The lines create movement and completely change the look of the page if I add a painted page behind the cuts.

The Emotional Landscape

Give yourself permission to let your emotions choose the curve for your landscapes. They don't have to contain rivers or mountains, a sun or a path. They can be about the colors you chose for your emotions earlier in this section. They can be soft and gentle or harsh and angular, depending on how you feel. Work intuitively. Let your heart guide your hands.

What You Need

your journal

favorite pen for writing words

colored pencils or other coloring tools

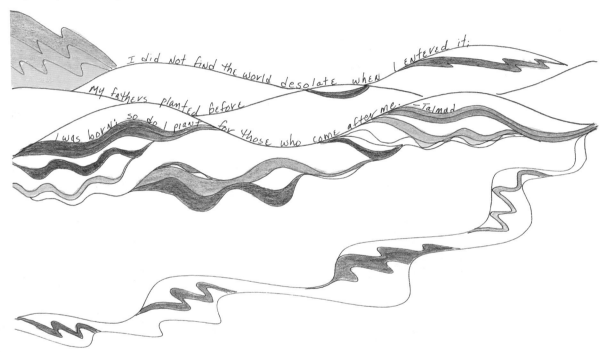

I did Not find the world desolate when I entered it. My fathers planted before I was born, so do I plant for those who come after me. —Talmud

1 Start by drawing the first line that gets your emotion on the page. Use a pencil the first few times. A pencil allows you to erase when you want to cross lines or if you change your mind about the design.

2 Now draw another line that follows the first. You can follow it closely, or you can suddenly move away from it, rejoining your original line a little later. That geography in itself is an interesting comment on your life—moving away from what came before and returning. Of course, you can choose to strike out in a different direction entirely. Keep adding lines that go over and under the original ones until you are satisfied.

Try not to overfill the page. An emotional landscape does not have to be big; it has to mean much.

3 You can add words between the lines. Write about what caused you to feel the way you did. Or finish these sentences:

- The place I think about when I want to be deeply happy is . . .

- If I could go to that place right now, I'd take these three things . . .

- The best part of the last movie I saw was when . . .

- My new favorite color would look great on . . .

The Imagined Landscape

Like emotional landscapes, imagined landscapes come from your dreams or daydreams. With imagined landscapes you can combine elements from "real" landscapes and emotional landscapes to create a world you designed yourself.

Enjoy drawing the sun? No reason your landscape can't have three of them—and they don't have to be in the sky or behind a mountain. Put them in the foreground if you like. Prefer the dark of night and how stars glow in the sky? No one can stop you from drawing star-trees or filling the roads or rivers with stars. This is your landscape, and you can invent what pleases you. There is no right and wrong, just interesting art. All of it is right for you. Don't be shy; be extravagant. If you aren't an extravagant person, be spare and simple. Make yourself happy or thoughtful. It doesn't have to look real, and no one will make you build it, so it doesn't have to be an engineering marvel.

What You Need

your journal

favorite pen for writing words

colored pencils or other coloring tools

Your art can remind you of a song or a photograph. It can be a close-up of one part. Fill some spaces with color, leave other spaces empty. Put in dots or tiny circles in one part and bold lines in another. Draw a big curve and a line following the curve, then fill it with straight lines.

When you are done, think, "This is the world I imagine" or "This is the world the way I found it. Now I need to change it." You are in the world to change it, one page at a time.

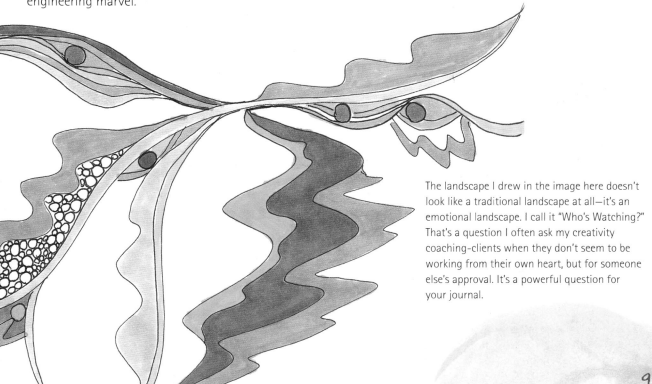

The landscape I drew in the image here doesn't look like a traditional landscape at all—it's an emotional landscape. I call it "Who's Watching?" That's a question I often ask my creativity coaching-clients when they don't seem to be working from their own heart, but for someone else's approval. It's a powerful question for your journal.

Making Meaning With Imagery

 Found art is the visual cousin to found poetry. Finding art in simple images is a way to stretch your imagination, to exercise your creativity. Without stretching and exercising, your creativity won't grow. Creativity may not be a muscle, but the more you use your imagination to see the world around you in interesting ways, the more reliably you will be able to develop creative solutions for problems. The examples in this section are fun and can be done at any time and by anyone. In fact, if you have a child in your life, the child may be an excellent partner to work with. Children are less concerned about being "right" and "cool" and will be happy to let their considerable creativity blossom.

You can still take lots of posed photos of friends and make scrapbooks or create digital albums of surprise snapshots—but you already know how to do that. In this section, think about taking photos of interesting items in your everyday world. These found-photograph designs can appear anywhere—in cracks on the sidewalk, paint splotches on walls, even hard-water stains on a sidewalk. They are never posed, they are never planned and they are always ordinary.

Looking Closer

If you have a creative eye, you can often see more than one design in a found-art photograph. Remember the game you played as a child—looking for images in clouds? Found-art photos work the same way. The pattern you see is yours to create and enjoy. Many people never see the wonderful, secret piece of found art. Once you see it, you can alter the image with colored pencils (or more) to create journal pages. Found art reveals itself to you slowly and can be seen in different ways at different times in your life. You can use one image over again and find different scenes, depending on your changing creative growth or emotions.

The Best Camera for Found Art

A photographer friend of mine answered my question of "What's the best camera to use?" by saying, "The best camera is the one you have with you." That camera is often in your phone. Many phone cameras are easy to use and technically quite good. If you prefer a small, easy-to-use camera, use the one you already have. Make sure it's fully charged and take it with you whenever you go out. The world is full of found-art photos just waiting to be discovered. Your camera doesn't have to have a flash, but it helps to be able to take close-ups, as a lot of found art is small and easy to miss.

Looking at this photo, most people would see (if they paid it any attention at all) a dead vine on a block wall. But look closer . . . do you see a stick figure with arms outstretched holding the middle of a long rope, part of which goes up and part of which goes off to the right side? You might draw a balloon on the top part of the vine, or a kite. Or add a lasso and turn the stick figure into a rodeo cowboy.

Maybe you're asking, "Photographs in a journal?" Sure. Photographs are particularly interesting because they show your world your way.

Photographs show details you don't notice now, or might not remember, but will make you laugh years from now. If you remember the 1980s, you might remember your first serious job or a big promotion. A photo will show you with wildly curly hair and shoulder pads that make you look like a line-backer—whether you are male or female. Photos have a way of reminding us of not just the truth, but the whole truth.

You don't need to know how to draw to use photographs in your raw-art journal. You don't need expensive equipment—use free or low-cost photography-altering software available online. I have software, but for this work, I don't use it. I print out the photographs and alter them with markers, colored pencils and watercolor pencils.

If you're still not sure how found photos are going to fit into your journaling style, here are some ideas to get your wheels turning:

- Shrink your photos and use them to create the mood of a graphic novel in your raw-art journal. A series of photos showing movement, time passing or something being created makes a wonderful page.

- Print your photos quite small in repeating strips on different colored paper for an Andy Warhol look.

- Print your photos out as large as your journal page, but lighten them before you print. Then use them as backgrounds and write on them.

- Print your photos on transparency film, smaller than the page, and cut out the middle of the page, slightly smaller than the transparency. Attach the transparency with photo corners and then create additional elements on the following page behind the transparency.

Transforming Ordinary Views

Look closely at the immediate area where you are now. Is there a shadow that looks like a cow? A pattern in the carpet that looks like a smile? A crack in the sidewalk that looks like a mountain landscape? You aren't doing photojournalism; you are giving your imagination free rein to run around and find interesting shapes and designs. Maybe you'll have to squint or turn your head a little, but you'll find it. Take a few photos. Often our mind sees images differently than our camera, so getting several views from different angles, with more light, closer or farther away, will help you find just the right vision you want for your journal.

The pleasure of this process is the thrill of finding something that becomes visible the instant you identify it. Did you love those drawings in children's magazines of a scene with hidden pictures—what looked like a forest had the outline of a teapot, rabbit, hat or book hidden in the detail of the leaves or bushes? Found-art photography will give you the same thrill.

Once you get used to using photography to capture your view of the world and using it in your journal, you can begin to enjoy found-art photography in different ways by altering the photos.

While many people love manipulating photos digitally, don't ignore the opportunity of working directly on photographs with colored pencils, watercolors or even the ink from the printer. If you have an inkjet printer, the ink can be smudged, pushed around and removed with water or alcohol. Experiment and decide what you like. But first you need photographs to work from.

Start by taking your camera and walking around your neighborhood. You'll be surprised at what you find.

Following are some photographs of ordinary objects that you can see in different ways if you squint and use a little imagination.

On my morning walk, I pass a block wall with a garden behind it. Because I live in a dry climate, the garden demands daily watering. The water contains a lot of minerals, and the minerals leach through the wall. You can see the hard-water mark on the wall.

Instead of seeing a mineral mark on the wall, I saw the outline of a mountain on the horizon. The dark water stain itself makes a great contrast, perhaps an approaching storm. And the vine in the upper part of the photo could be cropped out or left in and turned into clouds. I liked them as greenery, giving the wall a magic-village feel. Here's what I did with the image using colored pencils and markers.

The wall is now a sunrise in a mountain range. But it's not a realistic mountain range—the plant is still there and you can see the blocks in the wall. Those details aren't important. What is far more important is that there is a road that disappears into those mountains. Who would walk on that road? Who would the wanderer meet? What's behind the mountain range? It made a good writing exercise in my journal.

Print Pointers

Increase the size of the photocopy to make it easier to work with, then shrink it again when you scan it for your journal. You get more detail that way, too.

Print on different kinds of paper—photopaper, colored stock, transparencies—for different effects.

Here is a piece of dried leaf on a sidewalk. I didn't see it as a leaf at first. The image I saw first was of a woman in ancient times, carrying a jug of water on her shoulder. She's looking to the right, and it's a bit abstract. One of my friends saw a mother kissing her baby, and another friend saw a woman wondering about something, with her arm bent and her hand at her chin.

See what you would do. Make a photocopy of the image and see what happens when you play with it.

You can create journal prompts to think about while you are working, and write once the image is ready. Use this image in your raw-art journal to think about things we take for granted—clean drinking water, roads that take us where we want to go, food for sale at convenience stores. How different would your life be if you had lived in the desert 200 years ago? How much more would you have thought of water than you do today? This thought-path makes an interesting journal experience, one you can return to several times. And it all started because of a leaf on the sidewalk.

103

Wabi-sabi Images

There is a Japanese aesthetic called wabi-sabi. It honors the old, the worn, the incomplete. It is a beautiful way to enjoy the imperfect world we live in, as well as appreciate the creation and destruction that each season brings. Keep an eye out for wabi-sabi photo opportunities to increase the depth and pleasure of journaling.

This old, urban garage is an example of a wabi-sabi experience. The owner had started to paint it, and somehow a streak of blue spray paint appeared. Whether it was graffiti or an attempt to highlight areas that need to be repaired is left to the imagination. What I did see in this image is a seascape with cream-colored sand. Because there is little color variation, I sensed fog on that seascape. Can you see the mountains on the right and the cresting waves running to the left?

This image makes a good prompt for wabi-sabi ideas. You can write about what you have stored and forgotten in your garage. Or home repairs that need to be done and how repairing something changes it, and whether or not doing the repair gives you a feeling of satisfaction. If you prefer a travel theme, write about the trips you took in different cars that spent part of the time in a garage. Or how you feel about time spent at the ocean, or your favorite vacation as a child. Those simple photographs have a treasure of information in them!

Capturing Images of Change

Different seasons bring you different photographic opportunities. Be outside every day. Go at different times to see your neighborhood in different light. If you live in a climate with four distinct seasons, you have opportunities of changing light and a variety of wind, snow, ice and rain effects. Drying water on roads, ice patterns on windows or whitecaps on lakes give you an excuse to be outside with a camera. If you live in a climate with little seasonal change, look for subtle changes—the slant of sunlight, the changing position of the sun at dawn, blooming seasonal plants—all mark changing time. In this case I noticed condensation on a mailbox.

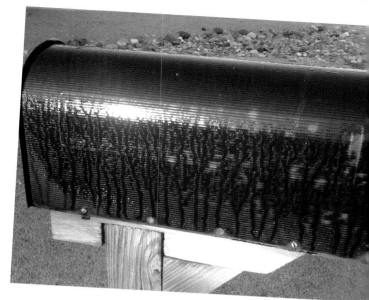

One morning I saw a mailbox that had heated up during the day, but as it cooled during the night, dew formed on the mailbox and ran down. On my way back the mailbox was dry. The next day I took the photograph, because it looked like a hidden forest in winter to me.

I could have cropped out the mailbox, leaving just the background, but to me, it's more pleasing to leave the original surface as a reminder.

As you work on the image, you can think about what shows up in your mailbox that you like or what can be used in your journal. Stamps are always nice, but the dates on metered mail can serve as the date on your journal pages. Flyers have big type you can use, and bills that come in security envelopes are even useful—the security pattern varies and makes a great collage background.

You can write about how using email has changed "snail mail," how a letter made you happy, or about someone who sent special mail years ago that you still remember.

No More Smears

Alcohol markers, like Copic, won't smear toner from an inkjet machine. They also work well as a first layer and can be a good background for colored pencils. I use watercolor pencils, but not water, as water will cause the toner to smear and run.

105

Beasts in Hiding

Many of the block walls in my neighborhood are covered in stucco—a kind of plaster that can be painted. Add water from rain or sprinkler systems and intense heat, and the stucco pops off a wall, leaving spots.

Creatures of all varieties can be found on walls or on sidewalks. As you create your beasts, you can decide to transform one from your nightmares to make them helpful. You can decide what you would say to the people and animals in your nightmare.

Of course, you can keep it a lot simpler and write about a pet you had or always wanted.

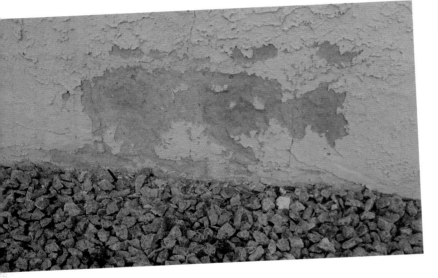

This one looked like some sort of beast to me. You can probably see more than one. Because you make up your own rules, you don't have to use every single spot. Or you can use just the small ones. In this case I used just the big ones. I decided to make this one friendly.

Notice that I trimmed away some of the unnecessary background. Technically, his front paw is not part of the spot, but part of the stucco that was raised. The small spots above? I pushed them back with light watercolor pencil because I didn't need them this time. Does a dog like this exist? Just in my imagination. Make your own rules—this is an exercise to stretch your creativity.

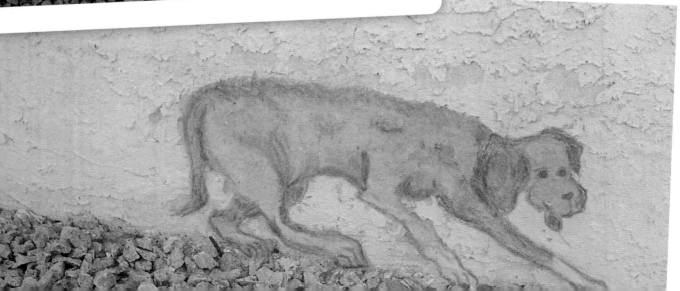

Imagery as a Background

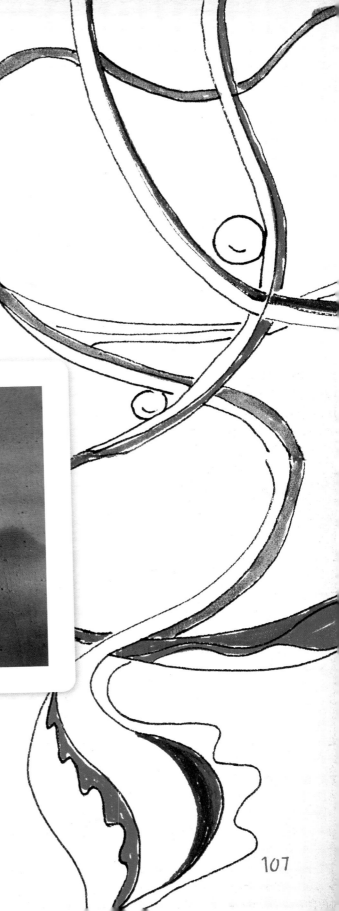

Sometimes your camera reads light or color wrong in a wonderful way. Shadows become blue, and reflections pick up the color from what they reflect. Photographing these frail images can create watercolor-soft images for you to use as backgrounds. Backgrounds on which you can add your own details, create your own stories. Backgrounds for collage areas, adding headlines. These private, subtle plays of light and shadow can change how you see an ordinary life.

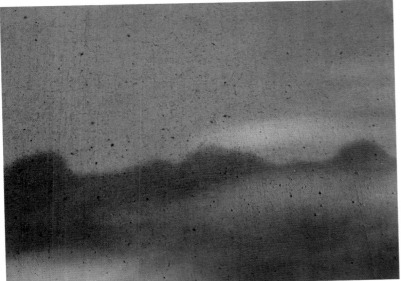

This photo has not been retouched. It's a combination of sunrise sunlight slanting through tree leaves very early in the morning. Water from sprinklers made dark spots; shadows and light created a photograph that looks like a watercolor landscape.

Photos such as the original one here can be fine as they are, but you could also add color or even gel pen stars and a sun, if you wanted. I decided to emphasize the dark and light areas because I wanted to use the photograph as a background image for my journal page.

107

Deep in his muddy memory, something makes • A ripple on the smallest space of thick and enigmatic water, something breaks • a thin stiff shaft of reed, grazes a stick • with wing or fin; disturbs the mist. He wakes. • the pre-dawn clamor in the fluent air • cannot drown out the subtle sound that aches • In his hollow cattail bones, and rattles there • What could it be, this sound or rushing where there are no wings, this snap of twig in rain • startling in the eye's white corner, hair • Rising on the arms again and again? • Nothing. An absence: losses beyond repair • forfeitures, white arms that would not stay warm while he learned what early hold he could bear • the sounds he hears are the ones that got away.

Using a natural landscape as the background made sense to me, as the poem* seems to take place during hunting season in the cold and damp. Using the image above, I drew wavy lines to continue the misty feeling of the landscape, then handwrote the poem on the lines. When I was done, I erased the lines.

I could have typeset the poem, but writing it in my own handwriting gave me time to get into the poem, to enjoy it and to make it part of the experience of creating a page. The time and effort was much more satisfying than printing it out, although that would have made it look more perfect. If you are a perfectionist, this step may seem awkward for a while, and then you will begin to feel much more pleasure in creating pages that are perfectly imperfect.

*Many years ago, I found a poem called "The Hunter" by Jane Greer in a magazine. The poem—which I interpreted to be about loss and losing love—moved me deeply. I copied it into my journal. This was before computers and search engines. Over the years, I searched libraries' card catalogs, but I never found the author. The poem moved into other journals and my blog through the years, and each time I used a different medium—collage, watercolor, ink—to add the poem. In 2010, I opened an email and saw a message from Jane Greer. It started, "I'm the Jane Greer who wrote 'The Hunter.'" After decades of not knowing anything about the person who wrote the poem, I was talking to the poet herself. She gave me permission to use her poem in this book.

Abstract Imagery Backgrounds

Now that your imagination is stretched and limber, choose photos that you take because you want to see something—something that may not be there originally.

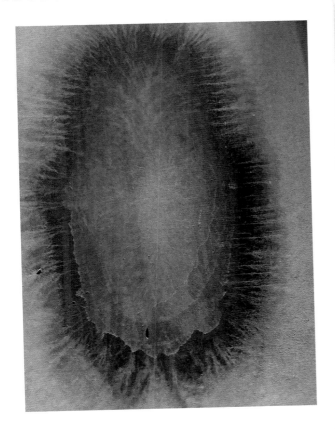

This photo is of a hard-water stain on a sidewalk. Sprinklers in my part of the desert spray water onto the sidewalk, and the sun and low humidity take away the moisture but leave minerals that interact with the minerals in the sidewalk, creating deep maroon and purple stains. The stains also reveal cracks and layers of minerals that are beautiful to look at and that hide wonderful, magical images! The outside rays in this photo remind me of the light rays around the images of Our Lady of Guadalupe. You might see a tree, or a woman with lightning over her head. What a great journal prompt! You could talk about stormy relationships, brilliant ideas that hit like a bolt of lightning or even who you could become with a bit of magic.

This is another photo for you to photocopy and work on by yourself. You can also choose to use it simply as an abstract design that you highlight, then make lighter so you can write directly on it and use it as a background.

Photography is a way to record not only exactly what is there, but also what you see in your imagination. You might want to do a swap with friends using one image that everyone can alter in different ways, then explain and swap. Enjoy your creative exercises in photography!

Storing Your Meaning

 How do you want to store your raw-art journaling? You can buy a blank journal, but don't limit yourself to one. Keep two, maybe three. One notebook for practical notes and to-do lists. (I also have a to-don't list, but that's for another book.) These utilitarian lists become your memory, freeing you from remembering details that will become important years from now.

In addition to a work journal, you can keep a raw-art journal. Mine is filled with ideas, notes on the seasonal changes (it's important to know that the figs were ripe two weeks later this year than last if I'm going to make jam for someone's birthday), ideas for drawings, rough sketches, tests of products like inks and watercolors, ideas for classes. My raw-art journals gave me the idea for this book; yours could give you the ideas for a career, a book or a path to exploring your life. Date every page so you can track your growth.

There can be journals for specifics, like vacations or restaurants you enjoyed. In this chapter, I'm going to share some ideas on how to make your raw art even more meaningful by creating your own journals.

Don't panic! This is not as hard as you think. We're going to keep it simple. If you are comfortable with Coptic stitching, if you can do a piano-hinge book with your eyes closed, wonderful. But you don't have to create hardbound journals; you can use the time-honored pamphlet, or you can create wonderful journals from unconventional materials like food packaging or Tyvek. Let's begin exploring our options!

Mutant Journals

In old-school learning, books had to be hardbound with even pages and precision stitching. The headband had to match the book cloth, and the tapes had to be exactly cut. If that brings you joy and satisfaction, you have found your style. But don't stop if you are not skilled at making perfect cuts. Remember what I said in the introduction—I didn't let the fact that I was flawed as an artist stop me. I wanted to make meaning, and that's what you can do, too. Choose meaning over perfection.

One of the great joys of accepting your imperfection is that it frees you to create imperfectly. Letting go of perfection opens a world of materials for you to play with. Experiment with different kinds of paper, covers and assembly. Pamphlets—a style of book that we'll take a look at first—become fun and fast. When you repeat doing anything because you enjoy it, it's called practice, and you get better at the technique without the agony of forced learning.

An easy way to start seeing possibilities is to turn your neighborhood into an art store. There are great finds at grocery, hardware, houseware, and drug- and office-supply stores. It's a little harder to see items as art supplies in some stores because they are cleverly concealed as cookie boxes, hinges, drawer liners, dental floss and mailing envelopes.

I had to give myself permission to use nontraditional items and put together books in simple ways. I used to beat myself up because what I created wasn't a "real book." Lucky for you, you can be much kinder to yourself because I've already given you permission to use whatever materials you choose. If you like, you can do as I do and refer to these journals as "mutant journals" to explain the motive behind creating something out of the norm.

I have a few journal projects I want to share with you, but first we need to see how these journals will be held together, and for that we'll use a very easy binding method known as the pamphlet stitch.

Pamphlet Stitch

Pamphlets are folded, sometimes stitched, pieces of paper that have been used to show ideas since the 1300s. They became popular in the 1600s as a way to pass around news, poems and essays. In 1776 Thomas Paine wrote *Common Sense*, a pamphlet that encouraged the American colonies to break from England.

The joy of pamphlets is that they can be fat or thin and stitched up in minutes. They can be large or small, use up papers you have or be elegantly designed to show off some great raw-art pages.

Here is the basic stitch we'll use for several handmade journals in this chapter.

What You Need

two or more sheets of paper folded and stacked together

pencil

ruler (if you are a stickler for measurements)

book awl (If you use heavier papers, you can use an awl from the hardware store. You can also use a needle held in a pair of pliers.)

sturdy thread (bookbinding thread, waxed linen—2-ply for lighter papers, 4-ply for heavier papers—pearl cotton or embroidery thread)

bookbinding needle, darning needle, or other needle with a big eye

Pamphlet Stitch

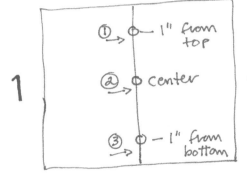

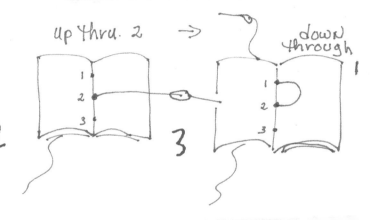

1 With your folded paper stack open, use a pencil to make three marks along the crease: one in the center of the crease line and then one above it and one below it, each about 1" (3cm) from the edge of the paper.

2 See that your pages are aligned and are nestled correctly together. Hold the awl in your dominant hand and gently poke a hole at the top mark, then fold the cover over and poke until you just see the tip of the awl appear through the outside of the book. Repeat for the other two holes.

Cut a length of thread about 24" (61cm) and thread it through your needle. Thread the needle through the center hole from the outside of the pamphlet to the inside.

3 Now thread the needle down through the top hole (number 1 in the illustration) from the inside to the outside.

Afraid of Measuring Up?

Do you find rulers frightening? How about your fingers? You have handy measuring tools right on your hands! The distance from the center crease in your first knuckle (closest to the nail) of your index finger to the center crease below it on the same finger is about an inch (3cm). It makes a handy measure.

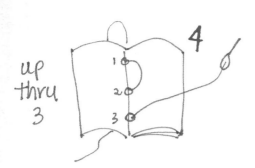

up thru 3

4

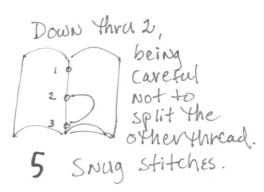

Down thru 2, being careful not to split the other thread.

5 Snug stitches.

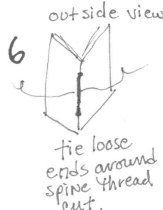

outside view

6

tie loose ends around spine thread cut.

4 Thread the needle up through the bottom hole (number 3) from the outside back to the inside.

5 Taking care not to run the needle through the thread that's already there, thread the needle back through the center hole (number 2) from the inside to the outside. Pull the stitching snugly.

6 Finally, tie the two tails around the thread that runs the length of the spine. That's it! You've created a pamphlet.

Because this stitch is easy, you can make pamphlets to carry around and write in while you are waiting—for coffee, a meal, a ticket or a doctor. Spontaneous writing and sketching can be just as interesting as planned journaling.

Methods for Making Your Own Deckle-Edge Paper

1. **Fold and knife.** *Fold the paper where you want the deckled edge. Using a steak knife or other knife with well-honed serrations, cut through the fold, from inside to out. Use small strokes and a sharp knife, close to the fold. No big strokes, no hard pulling. Sawing motions work best.*

2. **Water.** *Using a portable watercolor brush, "draw" a line of water with a brush, then tear. The portable brush works like a fountain pen, and the water comes out in a smooth line. Let the water sit. Once the paper has had time to absorb the water, put your non-dominant hand on the paper to hold it, and use your dominant hand to pull the paper away from the water line. It is important that you pull to the side instead of up.*

3. **Water method and sized paper.** *If the paper is sized (which makes it water resistant), you will need to help the tear along. Use a metal straightedge placed against the water line. Pull the paper away, as in no. 2, above.*

4. **Sewing machine.** *Take the thread out of your sewing machine. "Sew" to create perforations along the paper. This is also great for curves. I like to put the holes close together. Starting at an edge, pull the paper apart slowly.*

5. **Craft, coping or jewelry saw.** *Use a sharp blade. The thicker the paper, the bigger the tooth of the saw needed. I use a jewelry saw and fine blades. Put the paper to be cut on a cutting mat, draw the line you will cut with an aquarelle pencil in a nice pastel and simply saw the paper along the cut. Any edges that are too ragged can be wet with a paintbrush dipped in water and then pulled even with a tweezer. Using an aquarelle pencil automatically adds a hint of color.*

6. **Crease and tear.** *This works best on lightweight to medium-weight papers. Fold and crease the paper, using a bone folder, a ruler or your fingernail. Turn the paper over, so the original crease is on the inside. Crease again. Open the page and put your nondominant hand on the paper to hold it, and use your dominant hand to pull the paper away from the crease. Pull sideways, not up.*

Cookie-Box Journal

Yes, the cover of this journal really is a cookie box. And while I love lemon cookies, I bought the cookies because I loved the box—the color, the coordinated stripes, the back filled with cheery copy, the size. The whole package appealed to me.

While cookies were the purpose for this art supply being in existence, it might be packaging of a different food stuff (or non-food stuff) that catches your eye as you wander the aisles of your local market. This process will work on just about any package.

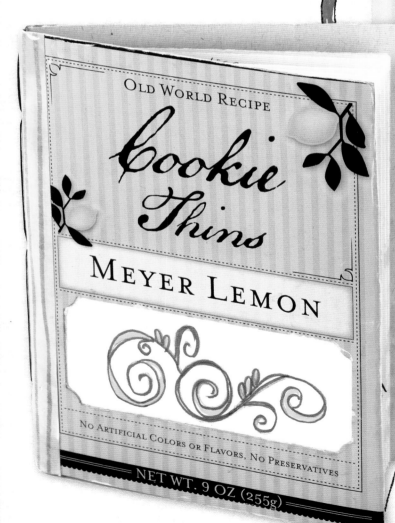

What You Need

interesting cookie box (or other packaging)

craft knife

metal straightedge

cutting mat

paper for pages

decorative paper to cover the inside box cover

white glue or gel medium

glue brush or old credit card

parchment paper

scissors

Tyvek tape, 1" (3cm) width roll

bone folder

markers (such as Pitt pen brushes or Copic markers)

two or more sheets of paper folded and stacked together

book awl (If you use heavier papers, you can use an awl from the hardware store. You can also use a needle held in a pair of pliers.)

sturdy thread (bookbinding thread, waxed linen—2-ply for lighter papers, 4-ply for heavier papers—pearl cotton or embroidery thread)

bookbinding needle, darning needle or other needle with a big eye

1

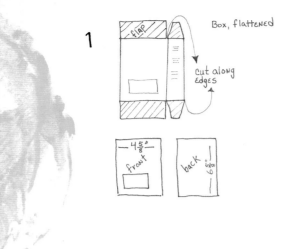

Carefully pry your cookie box apart at the seams where it's glued so you end up with a flat piece of cardboard packaging. Decide which portion you would like to use for the cover and cut two pieces the same size—one for the front cover and one for the back cover. An easy way to cut a straight cover is to work on a cutting mat with a grid. Sometimes it's easiest to make the first cut along a fold in the packaging, if that works out with your design. Make your cut using a craft knife and a straightedge. Align the cut edge on a grid line on the mat and place your straightedge on a perpendicular line where you want the next cut. Continue with the other cuts for the second cover. Here, it just so happened that my covers worked out to be 4⁵/₈" x 6⁵/₈" (12cm x 17cm), but if yours are a different size, that's fine; the rest of the process will still work out the same.

2—3

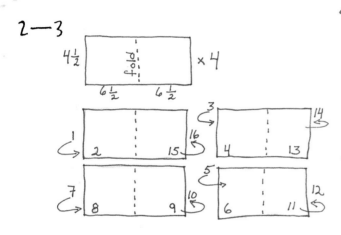

Create a signature of pages by cutting or tearing (see Methods for Making Your Own Deckle-Edge Paper on page 114) the paper you want to use, folding each piece in half and stacking them together. How will you know how big the pages need to be? When folded, they should be about ¹/₈" (3mm) smaller than the cover. In my Lemon Cookie book, there were four sheets of paper, resulting in an eight-page book. You can use more, depending on the thickness of your paper, but be mindful not to use too many sheets or the book won't close easily.

If you already have a plan for what you're going to journal on the pages, you may wish to complete them at this stage. This way, you can easily replace pages you don't like or want to do over before it all gets bound together. Then again, maybe you don't know what you'll use this journal for yet, in which case, there's no pressure—just leave the pages blank and continue on to the next step! The illustration shows four sheets of paper with the pages numbered prior to being folded and stacked together.

4

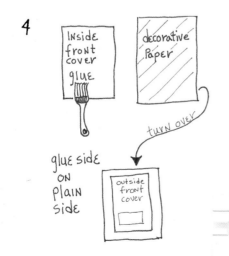

Cut two pieces of decorative paper, slightly larger than the cover pieces. Using a brush or old credit card, apply a thin coat of glue or gel medium to the back of the front cover piece, making sure you get adhesive all way to the edges. Place the cover glue-side down on the decorative paper (also facedown if it is printed on one side only). Turn the cover over and use your fingers to burnish the paper to the cover. Work from the center out to remove bubbles. Repeat for the back cover.

Bringing Order to Pages

A note about working on pages that aren't connected: One page will be th center spread—and you can use it to draw or write all the way across the middle. On the other pages, however, what appears on the left side will be nowhere near what you put on the right. However, the writing and images on the back of one right side, will be right next to the back of the left side o another sheet. It helps to number the blank pages so you know the page o

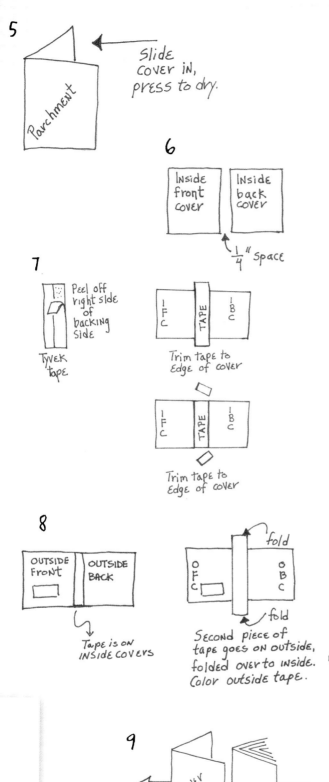

5

Slide cover in, press to dry.

Parchment

6

Inside front cover | Inside back cover

¼" Space

7

Peel off right side of backing side

Tyvek tape

I F C | TAPE | I B C

Trim tape to Edge of cover

I F C | TAPE | I B C

Trim tape to Edge of cover

8

OUTSIDE Front | OUTSIDE BACK

Tape is on INSIDE COVERS

fold

O F C | | O B C

fold

SECOND piece of tape goes on outside, folded over to inside. Color outside tape.

9

Cover | Pages

5 Stack the covers between parchment paper and then stack underneath at least three books. (Old phone books work great for this.) When they are completely dry, trim off any excess paper from the covers, using a craft knife on the cutting mat, or cutting carefully with scissors.

6 Place the front and back covers in front of you, with the insides facing up, the front cover on the left and the back cover on the right. Leave about ¼" (6mm) of space between the two.

7 Cut off a piece of Tyvek tape that is 1" (3cm) longer than the height of your covers. Peel the backing paper up halfway down the entire length of the tape. Hold the tape over the covers so it's centered over the gap. Gently place the exposed sticky half on the left (front) cover. Burnish the tape a bit to make sure it's adhered. The tape should stick about ½" (13mm) over the top and bottom edges of the covers. Lift the front cover and tape off the table and peel the other half of the backing off. Turn the taped front cover over so the sticky side is up, and then carefully press the back cover into position, inside facedown. Burnish the tape down again and carefully trim the excess tape off using a craft knife.

8 Cut a second length of tape 1" (3cm) longer than the height of the cover. Set the open cover in front of you, outside face up. The sticky side of the tape holding the covers together should be face up as well. Center the new piece of tape over the gap and use a bone folder to burnish the tape to the front of the cover and to the other piece of tape. Wrap the overhang of tape to the inside of the cover.

Tyvek tape takes color beautifully, particularly with markers. For my Cookie Box Journal, I started with yellow marker and then added brown stripes to mimic the box's stripes. Decorate your spine to match your covers as you see fit.

9 Stack your pages inside of the finished cover and bind it all together using the pamphlet stitch method on pages 113–114.

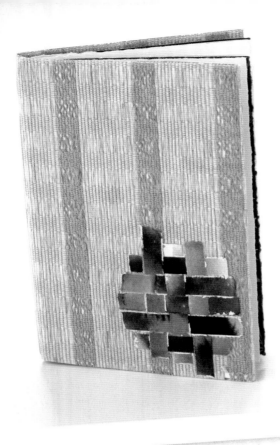

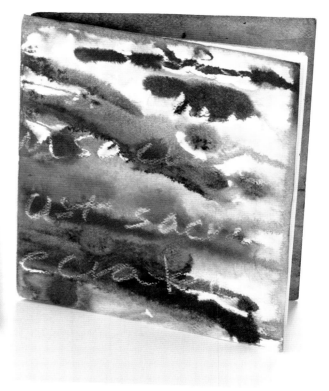

You don't have to limit yourself to cardboard boxes for fun covers. For this journal, I used shelf paper. It is made of tiny pieces of sustainably harvested bamboo, woven with hemp. I used the glue-backed paper over a piece of Davey board (bookbinding board). The paper weaving is made with pieces of ink-dyed paper from another project. I put it in the lower right corner of the front cover to make it easy to identify which way to open the book. There are many wonderful shelf-lining materials that make great book covers.

Another great material to use as a cover is heavy water-color paper—hot-press or rough-press. Using a grease pencil (also called a china marker, chinagraph pencil, wax pencil or tile pencil), I wrote in big, loopy writing before I started. The phrase is from a poem I found. You can write your own, too. The wax in the pencil acts as a resist. You can then spray water on the paper and drop black, brown and sepia ink onto the wet paper. When it is dry, you can find more than color—do you see an angel at the very top, flying from left to right, protecting the beast below? Even if you don't, it's an uncontrolled, wabi-sabi cover whose results will delight you.

Accordion Books

Accordion books are simply long pieces of paper folded back and forth like a fan. You can use each section of paper between folds as a page or write across several sections of paper (pages) at a time. Because the book has a front and a back, you can tell a new story on the back or finish the writing you began at the front.

What You Need

long piece of paper (I like to use a third of a full piece of watercolor paper, so I start with strips that are about 6½" x 25" [17cm x 64cm].)

Basic Accordion Book

Don't underestimate the humble accordion folder. They can be beautifully illustrated, pierced or collaged. Pages can become pockets that hold cards, photos or another accordion folder. Accordion books are easy to make. The simple directions for this version yield a four-page book.

1 Take a long piece of paper and fold the sheet in half, matching up the short ends. Then open the paper.

2 Turn the sheet over and fold each end to the crease in the center. Keeping these two folds down, fold the book in half again along the existing crease. Presto! You now have a small book about 6" x 6" (15cm x 15cm).

There are many variations you could do on this basic structure. You could try what I did here and open the book, then cut a wavy line starting at the left and running to the right. When you refold the book, you have a 3-D mountainous landscape scene.

Another idea: Use an unthreaded sewing machine to puncture lines of holes across the accordion folder, adding textural dimension to the piece. Alternatively you could do this by hand with an awl or T-pin. Alternating the sides of paper you punch from (or sew on) makes for a more interesting texture. Then, using one or more line drawing techniques from pages 72–81, draw around the holes to create interesting designs. I call this paper tattoo—but you never have to worry about being stuck with one design for the rest of your life like a real tattoo.

Index-Card Accordion Book

Because of the characteristics of index cardstock, this technique is best for sketching or colored pencils. (Markers soak through most index cards, but don't worry too much about this; you can easily attach two index cards back to back using a glue stick or stitching.) Index cards are easy to pack when you travel, whether it's a camping trip or a trip to the dentist. Index cards are great for notes, and if you mess one up, you don't have to worry—they come in packs of 1,000. There is no measuring to create an index card accordion folder—just tape the pieces together. Another advantage: you can make it as long or as short as you need to and add to it later.

What You Need

index cards, 8 for a one-sided book, 16 for a two-sided book

washi-paper tape (colorful Japanese paper tape made from gampi, mulberry or hemp fibers), or other colored tape of your choice

glue

cardboard, at least the same size at the index cards

cork drawer-lining sheet, the self-adhesive kind

craft knife with a sharp blade

cutting mat

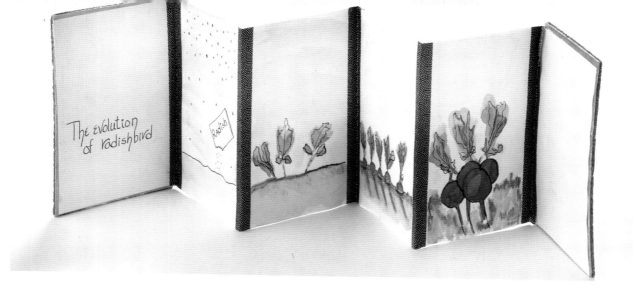

1. Use small or large index cards to create pages that delight you. This could be a series of thoughts and art that flows from one page to the next or a group of individual pages that each stand on their own. Once the pages are completed, lay out the cards in a line in the order you want them. The cards should almost touch one another, but leave about $1/16$" (2mm) of space between them to make the book fold up easily.

2. Use washi tape (or the tape of your choice) to connect the cards along their long sides. You could use one color of tape for the entire book, or one color on one side and a coordinating color on the other, or a different color between each card.

3. To create a cover for your book, tape one piece of cardboard to each end of your book to act as support for the front and back covers. Begin with a piece of cork sheet that is slightly larger than your index card. Peel off the paper and place the front cover facedown on the sticky side of the cork. Cork doesn't have a grain, so there is no need to place it too carefully; it will always look good. Trim the excess cork with a sharp craft knife, working on a cutting mat. Repeat for the back cover.

Use your own creative ideas to make these easy books. Make a series for holidays or for important events in your family. Make one for each season or for the progress in your garden. Or make up a different life you would like to live. Once you start, the road of exploration will lead you to ever-new discoveries of your own. You will be hooked on creating and meaning-making for life.

Cover-to-Cover Coverage

If you don't want to use cork material, another easy solution—if you're using 4" x 6" (10cm x 15cm) index cards—is to use watercolor postcards; they are generally the same size. If you can't find watercolor postcards, you can also cut heavy watercolor paper to size.

Monsoon Papers

This project is a fun way to create paper used as a cover for your handmade books. You could also use these papers for collage or as background pages in your journal.

Coloring your own paper has some advantages. You can choose the colors you like or that match the book. If you like to use the same papers throughout your journal, you can color the same weight papers as the ones you are using in your journal. These papers also make nice photo mats or bookmarks.

Monsoon Papers are watercolor papers saturated with bright inks. Named for the summer monsoon storms in the Sonoran Desert, the creation of Monsoon Papers is an exercise in giving up control of the outcome. Some papers will be more to your liking than others. Originally I created Monsoon Papers using wind, rain and whipping tree branches. These instructions assume you want the same results without running around outside, dodging lightning and getting drenched.

This is not a fast (or tidy) project; leave at least one hour and prepare to be messy. Dress in old clothes that you don't mind ruining—old shoes, too.

What You Need

watercolor paper or other sturdy paper, at least 95-pound text weight

flat ground, covered in plastic (Your papers are going to drip, so keep away from walkways and walls.)

water hose with a variable spray head, set on the finest mist possible

inks (India inks, stamp pad re-inkers or other inks that come in a drip bottle), assorted colors

parchment paper or other clean paper

iron

acrylic medium

large, flat bristle brush

shimmery watercolor paints

fine gold acrylic paint

interference gold acrylic paint

4 Pick up a sheet by two corners and allow the colors to run over each other. Do not overmix. Once most of the page has color, hold one corner and allow the ink to drip onto another sheet. If you have a tree handy, hang the paper over a low branch and place another sheet underneath the dripping one. Keep moving the sheets, one hanging, one dripping, until all have random inks dripped on them. Avoid rewetting as this dilutes the ink.

5 Once all the sheets have been colored on one side, turn off the hose and let the sheets dry. Inks are not colorfast, so the color will run when you get them wet. You can heat set them by ironing each sheet between two sheets of parchment paper.

6 To color the second side, spray the first side quickly, and turn the paper to the blank side and spray more heavily. This keeps the paper from curling.

7 Repeat the process to color the second side as you did the first. The first side will start to run. You will have one vibrant side and one softer side. Iron the second side, too.

Every page is different, unique and beautiful. You can seal both sides with acrylic medium to prevent the color from running if you are going to use glue to attach the papers onto some other substrate.

1 Choose a color palette for several pages. Group the ink bottles together so you can grab colors without sorting through bottles.

2 Put the sheets of paper flat on the ground. Spray them till they are thoroughly wet. Flip them over so they get wet on both sides, all the way to the edges.

3 When they are completely wet on both sides, drip ink near the edges of one side. Avoid the middle. The ink will creep into the paper and spread. This ink is highly concentrated; do NOT overapply ink. If you are using one color family—blues and purples or blues and greens, use a small portion of a contrasting color. Work on one side only.

Eventually you will create a page that just doesn't work. It's too muddy or has nothing interesting happening in the surface design. Don't worry; you can still have an interesting sheet. One of these techniques should work. Use these techniques before you seal the sheet with acrylic medium.

1 Use a shimmery watercolor paint and lots of water. Load a watercolor brush with one shimmer color, something that coordinates with a piece of the paper. Touch the brush to the surface, allowing the water and paint to soak into the watercolor paper. You are working on an unsealed sheet, so some ink will also work its way into the water, leaving streaks of ink and shimmer. You can see this effect on the left half of the shown page.

2 Using a bristle brush, apply about a teaspoon of acrylic medium to the page. It should be the consistency of light cream. Put a drop of fine gold acrylic paint or interference gold on top of the medium. Do not mix. Paint the medium over the paper. The gold will swirl and brush over the color, adding an overall, uneven shimmer. You can see the effect on the right side of the paper here.

Resources

Search engines and Internet shopping have cut down on the need for a list of specific resources. However, I used a number of tools that may be hard to find or that I purchased at specific stores.

This list does not include the websites of artists I visit regularly, because there are too many. I use Facebook, Flickr, Twitter and YouTube to find art journalers, bookmakers, box makers, origami, watercolor and acrylic artists and then learn from them. I encourage you to do the same. You don't have to friend or follow them forever, but then again, if you make friends, you might.

My main concern is for the small local store in your area that needs your support to continue to operate. That said, maybe you live in areas where there are no small stores, and Internet or "big-box" shopping is the only way art can be accomplished.

When you can support the artists who own and operate stores in your community, you build your community, the community that you hope will support you as an artist. Go to classes there and teach what you know to share your gift. It builds a community of art, which we all need.

None of these stores have asked to be mentioned or are paying in any way to be mentioned.

Here is a list of my own local stores at which I've taught and/or shopped:

Arizona Art Supply
Phoenix, Scottsdale, Tempe, Sun City
http://www.arizonaartsupply.com

Changing Hands Bookstore
http://www.changinghands.com

The Craft Retreat
http://www.thecraftretreat.com

The Creative Quest
http://www.thecreativequest.com

Mystic Paper
http://www.mysticpaper.com

These stores aren't local, but are artist-owned and have specific equipment I love:

Hollander's

They have a selection of papers I love, including Arches Text Wove and Arches Cover in black. Their staff knows the products when I call.
http://www.hollanders.com

Volcano Arts

Christine Cox, the owner, offers the best bone folder I own. It's made of silicon, not bone. I also use it to turn corners when covering books with decorative paper. Christine is very knowledgeable about what she sells.
Volcano Arts: http://www.volcanoarts.com
The paper folder: http://volcanoarts.com/cart/book-binding/index.htm#Folding

Internet stores that I use for specific products:

Daniel Smith

Located in Seattle, Daniel Smith is a good source for interesting watercolors containing real ground minerals. I also like their watercolor sticks—dense, pure watercolor in stick form—for travel. Their videos are short enough to learn from and long enough to give you the detail you need.
http://www.danielsmith.com

John Neal Bookseller

They have a good selection of flat-headed calligraphy pens called automatic pens.
http://www.johnnealbooks.com

Index

About Quinn

Quinn McDonald wanted to be an obedient, dutiful wife and patient mother, but she was born at the wrong time. She became a writer—in ad agencies, in corporations, at a newspaper. Traveled all over the world. Took notes. There was always that restlessness—that raised eyebrow that wouldn't behave. Then one day, during a performance review, her boss said, "You are different and seem to enjoy it." It was not a compliment. The clock on Quinn's job security ticked to an end. From that day on, Quinn listened to her intuition, quit looking for meaning in life and began making meaning. She is a certified creativity coach who creates art, writes, teaches and rides her motorcycle in the amazing landscape of the Sonoran desert with her husband, Kent. Her son, Ian, is a professor of music theory at Yale University. Quinn is grateful that she inherited her father's wry sense of humor and her mother's ability to make incredible gravy from scratch.

Discover more inspiration with these North Light journaling titles.

Journal Spilling
Diana Trout

In the pages of *Journal Spilling* you will learn many new, cool mixed-media techniques, but the biggest surprise may be what you learn about yourself. There are no lines to stay inside of here. You're free to quiet your inner critic and spill color (as well as your thoughts) all over the page. Open up and see how safe a place your private journal can truly be.

paperback, 128 pages, Z2926

Journal Bliss
Violette

Unleash your inner eccentric! *Journal Bliss* provides pages and pages of artistic inspiration designed to encourage you to embrace your wild side and express your true self visually in your journal. You'll love Violette's style of interactive illustrations, doodles, tutorials, tips and prompts. *Journal Bliss* overflows with creative ways you can use a variety of artistic mediums to start your own visual journey today!

paperback, 128 pages, Z2784

The Journal Junkies Workshop
Eric M. Scott & David R. Modler

The Journal Fodder Junkies are on a mission, ready to arm you with all that you need to explore artistic ways of recording your life and thoughts. Part sketchbook, part diary, part notebook, part dream journal, part daily planner, part to-do list and part doodle pad, the art journal is different things to different people. Whatever it is for you, *The Journal Junkies Workshop* contains the covert inspiration you need to get started.

paperback, 160 pages, Z3942

These and other fine F+W Media titles are available from your local craft retailer, bookstore, online supplier, or visit our Web site at www.CreateMixedMedia.com.